HOLLOW COMPANY

A MEMOIR OF SURVIVAL

JESSICA HMIEL

Charleston, SC
www.PalmettoPublishing.com

Hollow Company

Copyright © 2020 by Jessica Hmiel

All rights reserved.

First Edition

Paperback ISBN: 978-1-64990-456-0
eBook ISBN: 978-1-64990-455-3

In loving memory of the fierce Kelley Elizabeth Stage.

Many nights I sat in the dark, calling on your spirit, with a bottle of red in hand. I begged you to lend me an ounce of your bountiful strength to continue writing. You cloaked me with my request, and so much more. 'Tis an honor to have been your friend.

Kelley, this book is for you. It's for me. It's for all the fighters reading this, finding their story in my words sprawled across its pages.

May all our monsters rot.

PROLOGUE

It's November 2017. I peer out my picture window overlooking the hectic intersection below. I steal a deep breath as a scooter nearly hits a pedestrian on the sidewalk. That was close. Why do they always drive where they don't belong? The lines of vehicles weave through one another without signaling. Just a quick honk to signify their movements. Organized chaos, truly. Green taxis as far as the eyes can see, their lights illuminated to let you know they're full. It's rush hour now.

The day's sky is fading to night, and the buildings are coming alive. My husband, Corey, will be home soon. Where's the day gone?

I'm living in Hefei, China, with nine million others. But sometimes I've never felt more alone.

My mind drifts to memories of the past year. Corey and I've made the most of our time here, regularly vacationing in foreign countries. Yet despite my best efforts, happiness evades me. I should feel more fortunate, for I live a life I've always dreamed of. Prayed for. The guilt consumes me, but I shouldn't allow it to. I nearly paid the ultimate price for this freedom. In my old life, I was caged. But those bars are long gone, and my wanderlust desires are able to flourish. So what's my problem? *Why am I not flourishing?*

I'll do better tomorrow. I'll be happier tomorrow.

As I wait for Corey, I get on Facebook. Man, I love this app. Online I can be whoever I want to be. I flick my finger through my own profile. A photo of my friend Jo and I in the middle of a vibrant red poppy field shows up. We're smiling ear to ear at our discovery, a sea of flowers stretching far into the distance. It's beautiful for sure, but it's not the whole story. I must've canceled plans with her four times before that trip. Each time I sat in my hotel bathroom, dressed to go, when a blanket of panic tucked me in. Adventures were replaced with heart palpitations, sweaty palms, and nausea. Jo understood. She always did.

I scroll some more, and there's a smiling selfie I'd taken on a date night with my handsome husband. Despite the warmth that takes me over when I look at the photo, I can't help but feel bad for him. What it must be like to have a wife like me. One who has an anxiety attack every time she hears honking horns. Loud noises are my kryptonite.

Another timeline flick brings me to videos of Corey and I on a drunken adventure in Seoul, South Korea. I smirk as I think of all the lemon drops we did that night. Each one I downed made me more tolerable. He's a saint for always taking care of me. For knowing exactly what I need in the moment.

Looking at my profile, I'm aware I'm the type of woman that makes others recoil. They get on Facebook in the morning, with their fingers mindlessly spinning through their feeds like the Wheel of Fortune. Their fingers stop scrolling at my morning post. There I am. With my perfect marriage, living the dream and traveling the world. I'm sure they gag into their coffees, thinking, "Fuck her. *She* doesn't deserve to be so lucky!" Snidely they comment on my post, telling me how lucky and blessed I am to have such "perfect life."

From an outsider looking in, I can understand their disgust. Online spaces show experiences through a rose-colored filter. Social media is a beautiful tool, as it gives us a platform to connect with others and share our innermost thoughts. But facades are put on; we are fake. All of us are guilty—they as much as I. Their kids have been assholes all day, their son wouldn't eat his dinner, their dog shit on the floor, their teenage

daughter told them she hates them, but that's not what they posted, right? Of course not.

I show you the light to shield you from my darkness. Darkness that I know would send you running. It always does.

The truth is, we all have it. We've taken that darkness, balled it up, and pushed it into the depths of our souls. I tried to keep it there by stacking as much goodness on top of it as possible. No matter how wonderful life is now, pain and darkness are like oil. You can try to water them down, but they'll still find a way to float to the top.

As my mind starts to wander, and sinister memories begin to bob their ugly heads, Corey arrives home from work. He's dressed in a blue-and-white-checkered button-up, khakis, and a smile. The smell of his cologne wafts to me as he shuts the door. I can feel his light pushing my darkness back into the distance. I'm all better, for now.

"How was your day, babe?" he asks as he removes his jacket.

"It wasn't bad. I took the subway down to the mall. Then I walked over to Lord Bao Park and took some pictures of the curved bridges by the water. It's such a great spot for people-watching," I say, thinking of the old couple I watched twirl around with one another as their Chinese tunes surrounded them. Their steps and love so youthful. "I just got back an hour ago. You'll be happy to know I didn't even get lost once!"

"Sounds like you had a better day today," he responds before pushing my hair to the side, kissing my forehead. "Let's order room service and watch some Netflix."

"Perfect." Thank God he doesn't want to leave the hotel.

On a full stomach, and five episodes deep, my mind begins to wander again. I look over at Corey, and to no surprise, he's fallen asleep. Glasses on and all. Like clockwork, I remove them, cover him up with a blanket, and again go to the window.

The light above reflects off my wedding band and engagement ring. The glimmering rainbow catches my eye. Married. I can't believe someone like him wanted to keep me.

As my eyes well up at the thought, I look back out the window. China. If you asked me in 2012 where I saw myself in five years, the answer sure as shit wouldn't have been China.

I'm trying to deflect what's really on my mind, but it's useless. In the dead of night, my demons always come knocking. Without Corey's light to chase them away, I always let them in. I want to sleep, but I know I can't. My dreams will be haunted. By him. *It's always him.*

The pain I once lived will never be overshadowed by the pleasure I feel now. No matter how surrounded I am by others, I'll never forget isolation. As many smiles come across my face, I'll never forget the tears that fell from my eyes.

I wish when I met someone, I could just be an open book. Lay it all out there. Then they'd understand me. Why I am the way I am.

Ten years. That's how long it's been since I met the man that plagues my dreams, or nightmares rather. And each time I close my eyes, his abuse becomes a fresh wound. It almost cost me everything then, and it's still costing me now. Mainly my sanity. The regret for not leaving sooner eats me up inside. The shame of giving my all to someone for nothing in return, like a boulder weighing down my soul.

Why didn't I see it coming? I watch all the horror movies produced; you'd think I would've been prepared for the danger that was him. We expect monsters to claw themselves out from beneath our beds in the darkness of night. But real-life monsters aren't like that. They aren't always terrifying…at least not at first. They come into your life by surprise, disguised by charisma, a crooked smile, and whispers of sweet nothings.

1

It was ten years ago—2007—when I met Jared. Or was it yesterday? I can rarely tell the difference. It was a sweltering summer day in upstate New York, and I'd ventured into a rundown Sugar Creek convenience store in search of a blunt and some Arizona Tea.

But first, let me take you back to the summer of June 2006. I was in Bath, NY—a town that smells like cow shit and deflated dreams—and I'd just graduated. It's the type of place that everyone talks about leaving but never does. I would be different. I was a blond-haired country girl with giant dreams and gigantic blue eyes.

As I hopped around from grad party to grad party, friends spoke endlessly about their summer jobs and community college admissions. Blah blah blah. I don't know if it was the booze or them, but I was nauseated by the idea of staying in the area, or at those parties, for one more second. So I did another keg stand and chugged beer after beer, inwardly rolling my eyes, hoping to black out soon. I couldn't hear their stories that way.

Truthfully, no one talked to me about applying to college. My guidance counselor advised me to stick with my cosmetology training, because "I wasn't meant for college." I left her office empty handed, where others had stacks of applications. I knew that was her way of saying I was poor. I

didn't come from money. Mommy and Daddy certainly didn't have a college fund waiting.

I'd been dating Chris—an intelligent computer programming student older than I was—for a while then. At first, dating an older guy made me feel invincible. He was out of my league, with his proper college education and fancy sports car. His car had underglow lights and a DVD player; that's how far off base I was. I didn't have much to offer other than big tits and a drinking problem, but somehow I'd managed to snag him.

He'd travel down from Rochester to see me on the weekends during high school, and we'd always find a field to party in. Together we'd kill bottles of Red Hot and Aftershock until I'd get drunk and pass out, or cry. Typically, you could find us dominating the beer pong tables for hours on end. If I wasn't there, I was probably betting a bunch of boys that I could jump over a fire. We never missed a good party.

Right before graduation, Chris had been offered a paid internship outside of Utica for the summer and asked me to come with him. I was seventeen and going places, I believed.

Zoe was my only real girlfriend at the time. I had met her in cosmetology classes. She stuck out like a sore thumb in her punk attire and short tresses among a sea of bleach blondes. Me being one.

I was staring at her with pure curiosity through a mirror that sat atop her desk, as she was off task, sketching something. I nearly shit myself when she caught my gaze.

"What the fuck are you looking at?" she said with a stone-cold glare.

I began to stutter, caught.

"I'm just kidding, calm down," she said with a smile.

By senior year, she and I were inseparable. She still intimidated the shit out of me, even though she was the most easygoing person I knew. I could always count on her honesty about anything and everything.

Zoe and I attended Will's graduation party together. Will, the class clown, and I had been friends for what seemed like forever. He was my childhood sweetheart and first kiss. Will often ragged on me about my relationship with Chris. He couldn't stand him. Which we both knew was because he was "secretly" in love with me.

Zoe and Will decided to gang up on me as a last-ditch effort to get me to not go to Utica with Chris.

"Jess, to be honest, that sounds incredibly boring. And you know you're going to hate your life without us around," Zoe assured me before taking a long drag from her cigarette.

Little did I know, she was right.

Will cautiously asked, "Your parents are seriously just going to let you move away with this guy, with no plans or anything?"

I laughed my hysterical gerbil-like laugh. *He's kidding, right?* I defied my parents at every turn. Authority had no hold over me, so they rarely attempted to assert it. I was determined to leave, and no one was going to stop me.

Few realized the lack of control my parents had over me, even Will. They'd become parents early in life and learned as they went. As I grew older and made friends, I quickly realized my family was a bit dysfunctional. Most of my friends didn't know where I lived, and I certainly never invited them over. I was secretive about my home life, only exposing what I chose.

In our younger years, we were monitored by a sitter, but as we aged, that became my role. My parents worked a lot, and my mom, like me, enjoyed a good party. My dad wasn't a drinker; in fact, I'd never seen him drink alcohol in my life. But he was her keeper, and as a result, he was often gone too.

My three siblings and I learned fast how to entertain ourselves. Miraculously, we never burned the house down with one of our seances, or killed each other. I mastered making family dinners of ramen noodles and Kraft mac and cheese at a young age. Maybe even some grilled cheese if we were fortunate enough to have butter, bread, and cheese at once.

My sister Samantha—a tall, skinny, blond-haired, blue-eyed girl—was the eldest child. She was a year and four months older than me. Despite her age, I always tried to play the part of the "big sister." I tried to overshadow her in any way possible, which in many ways ended up pushing her away.

When she was still in high school, she'd moved in with her long-term boyfriend. I wasn't surprised when she admitted to being pregnant with my niece her senior year. By that point, we'd both been sexually active for years.

My sister Aleisha—a short brunette with piercing blue eyes—was fifteen at the time. She and I had been competing in a lifelong match to see who could be the biggest troublemaker. She'd won the gold medal when she gave birth to a baby girl at fourteen. Samantha's and Aleisha's daughters were born about a month apart.

My brother, Brett, was the youngest at ten years old. He was lanky and already beginning to tower over me in the way that boys awkwardly do as they're coming of age. Brett had difficulty forming a connection with our sisters growing up. Any relationship they had was severed by the birth of my nieces. The baby of our family had quickly been pushed to the wayside when my nieces became the youngest.

I'd always taken on the role as his protector, so I knew that my absence would gut him. The guilt I felt for leaving him to there to figure it all out alone was overwhelming. But I had to go.

Chris moved to Utica a few weeks before I graduated, and after my ceremony I joined him.

"Don't expect much. This place is tiny," Chris warned on our drive up.

When we arrived, I entered the apartment first. This was the smallest place I'd ever seen in my life. Was he sure this wasn't a walk-in closet instead of an apartment? I walked into what I assumed was our bedroom, half of which was occupied by a colossal piano.

I glanced back at him. "What's this?" I asked, pointing to the monstrosity ahead.

"It's the landlords'. They refused to move it but gave us a deal on the place. The other half of the home is used for giving music lessons." *Greeeaaat. Thin walls and kids learning to play instruments. This is hell. Oh well, at least it's not my parent's house.*

At first, I rarely left our apartment since A, I had no friends, B, I didn't know the area, and C, I didn't have my license. My parents were kind enough to get me a bicycle for graduation, no doubt because they were

nervous about my new situation. I was ungrateful and never bothered to use it. As a result, I spent my whole day on Myspace waiting for someone to post something new. A sure beginning to my social media addiction.

"You know, if you got a job, you wouldn't be bored anymore," Chris insisted.

Ew, no thanks. I really didn't want to work. Ugh. I'd honestly hoped I'd get to move here and relax. I'd just finished working years for Kmart.

Despite my reluctance, I put some applications out. Eventually, I got a call back from a local Wendy's, and I started soon after.

I enjoyed working there, but getting there was a hassle. I still didn't drive, and my Wendy's was quite far away. I hadn't thought my "fun summer" was going to include 5:30 a.m. wake-up calls and miles of walking, but there I was. *Maybe I should've just gone to college.*

Chris's work was much closer to Wendy's than our apartment was. I caught a ride with him and slept in his car until it was time to walk to work. I rolled down the windows, exposing myself to the unforgiving summer heat of the parking lot. Please God, I'd pray, send me a breeze. Heat exhaustion would clearly be my cause of death.

When my flip phone's alarm sounded, I groggily grabbed my plastic bag containing my uniform and meandered out into the sweltering heat. It was a forty-minute trek with no sidewalk along a fifty-five-mile-per-hour road.

Arriving drenched in sweat, I knocked on the door for the cleaners to let me in. In the public restroom, I changed out of my sweat-soaked clothes, wiped my body down with soapy water, and changed into my uniform. This was a lot of effort, especially for a measly paycheck I mostly spent on Junior Bacons and french fries.

The days were monotonous and dragged on forever. I lived for the few weekends here and there when we'd escape to Bath. Summer eventually came to a close, as did Chris's internship, and we moved back home. I was dying to have familiar faces and scenery.

Upon arriving back, we were bombarded with everyone's stories about their great summers and all the raging parties we missed. The familiar faces that I'd been longing for, I was beginning to hate. I'd lie about the

great summer we had and then change the subject. It was like everything was exactly the same: the people, the scenery, the bullshit. But something had changed, and that something was me.

We didn't really have a plan for when we arrived home, so my parents allowed us to crash in my old bedroom. But after a few days, I just couldn't stay there anymore. It didn't feel like my room. Or my home. It felt like we were squatting.

One night we went to Chris's mom and stepdad's house for a few competitive games of dominoes and cards. I lost as usual, but his mom made a killer dinner, so I was cool with it. They'd been doing work around their house, and they mentioned they'd been thinking of building a room in their basement.

"If you guys help us paint the upstairs and build the room in the basement, you're welcome to move in it while you figure everything out," his mother offered.

They lived outside Corning, which was only twenty minutes from our hometown but offered better jobs. Chris and I quickly discussed their offer and agreed it was a decent idea.

A few days later, we helped build our new bedroom. They framed out a tiny box just big enough for a bed, futon, nightstand, and TV stand. It wasn't much, but we didn't have much, so it didn't matter. We erected the walls and then covered them in carpet.

Who puts carpet on the walls? I'd never seen something so ridiculous. Oh well, it wasn't my house.

"I've got the outside of the bed!" I quickly exclaimed. "I'm not about to wake up with a rug-burned face." Everyone laughed.

Not wanting to come across as a freeloader, I soon began searching for jobs. I had to find something near, because God forbid I got my license. *Oh, what about Friendly's?* They were hiring. I wondered if they'd hire me even though I had no experience. There was only one way to find out.

The very next day, my phone rang. "Is this Jessica? This is the manager over at Friendly's. How are you?" an eager male voice asked.

"It is! I'm doing well, and you?" I responded with shock.

"Same, same. Look. We're short on servers and need to get someone in here immediately. When can you start?"

"Um...tomorrow?"

"Great. Come with two forms of ID, and dress in black pants and a polo. See you at eight a.m.," he said before hanging up.

The next day, I arrived for the breakfast shift. If you've never worked the breakfast shift at a restaurant, you probably don't understand why this was a terrible thing. Breakfast shift servers are referred to as "lifers" because they've been there for an eternity. They're gremlins who wake at five a.m. and hate each other, and they already hated me. Not that I blamed them; when I called sunny-side-up eggs "dippy eggs," it was likely the straw that broke the camel's back. We all have our flaws.

"Dippy eggs?" my manager yelled. "What are you, a fucking retard?"

I had only just started there, but I hated him. "You make my skin crawl," I wanted to scream. "You clearly only hire women because you get off on mentally abusing them. I'm not an incapable idiot."

"Why does he always blame me, even if it's the kitchen who screws up?" I asked the lead server, Shirley.

"Get used to it. If you figure it out, let me know!" Shirley responded.

A few days after my confrontation with the manager, a night-serving spot opened, and I quickly snagged it. Thank you, God! I knew it would be the same abuse, but at least it paid more. That was half a win. All the girls who worked that shift were around my age, and we quickly bonded over our hatred of our boss.

My first dinner shift was when I met Stella. She was an incredibly tiny thing, with pale skin and long hair. That night, as my section began to fill up, I got flustered. I messed up an order, and despite how busy she was, Stella quickly took pity on me and helped me fix it. We laughed in mutual misery, which became the foundation of our friendship.

She can play this kind waitress role all she wants, I thought; *I can tell she's got some rebel in her. We'll get along just fine.*

After one hell of a first night shift, I went outside into the impossibly cold winter air. I sat at the picnic table, waiting for Chris to finish his poker game and come get me. This habit of his was really starting to get

under my skin. Five minutes turned to ten, and well, you know how that goes. Just when I thought my ass had become a permanent frozen fixture on the picnic table, Stella came out the doors.

"Ugh…Jess? Care to explain why you're still here?"

Laughing, I replied, "Still waiting on Chris."

"You're insane. I'm taking you home," she said.

Now, based on first impressions of Stella, one would assume she probably drove a Civic or something cute and sporty. No. She walked past all those cars to the corner of the lot with the creepy flickering light. To my surprise she began unlocking the door to an old, slightly beat-up Cadillac. *Ha, I like this bitch.*

She started the car, and Lil Wayne blasted loudly from her speakers, the bass vibrating every bone in my body as we both smiled.

She drove the short distance to where I was staying, and before I got out, she asked if I wanted to go shopping with her the following day. After months of making essentially no human contact, I responded, "Hell yeah."

Eleven a.m. rolled around, and I was sitting on the front steps waiting. I could hear her bass approaching the house and smiled. Stella turned her music down just before making the right into our driveway, which I appreciated.

I was elated at the aspect of making a new friend. Starting over. The physical and emotional loneliness I'd been feeling was finally ending. After that day, we were virtually inseparable.

A short few days later, she looked at me and asked, "Do you smoke?"

By my next question, she probably gathered that I didn't—I asked, "Smoke what?"

She laughed, then I laughed.

I lied and asked, "Yeah, why?" Well, I didn't totally lie. I certainly wasn't a connoisseur by any means, but I had dabbled a bit. Admittedly, alcohol was my vice, not weed.

She said she was going to pick up a friend later to go on a "hilly," but I could come if I wanted.

A hilly…okay, whatever that means, I thought.

Excited to meet some more of her friends, I agreed. Stella drove into town and picked up her friend Kris. I'd heard her talk about him a lot, but I'd never actually met him. She could've warned me the man was _fiiiine_. Friends are supposed to share these details.

Into our town's surrounding hills, we drove on the first of many hillies. That's local slang for driving around on back roads, jamming out to music, smoking massive amounts of pot, and laughing your ass off.

Every once in a while, paranoia would set in that maybe a passing car saw we were smoking, but for the most part, I didn't give a shit. For the first time in a while, I felt alive.

As you've probably gathered by this point, Chris (not to be confused with Kris) and I had begun to fizzle out. We lived together, but there was an elephant in the room that we never discussed. I think it was over for both of us around the time we moved to Corning.

When you're young, you just want things to work. Staying had its conveniences. Besides, I didn't have any other prospects, so dragging it on felt easier.

As anyone who stays in this type of relationship will tell you, tensions were high. We both didn't want to spend much time with the other. Yet we resented the other's alone time or periods spent with friends.

Chris was working doubles at the local pub, and I was working nights at Friendly's. I spent my days getting high with Stella and Kris, and that was pretty much it. Chris had hobbies like bowling, poker, and beer pong. None of which I cared to be a spectator for.

Once in a while, he'd convince me to go back to Bath to go to a party, but I couldn't have been less interested. Those people weren't my people anymore. He'd do his thing, and I'd do mine, which worked fine for a bit.

Jump ahead to summer 2007. Stella and I were up to our usual shenanigans. We were out of blunts, and I needed some snacks to get me through my upcoming munchies session. She pulled the Caddy into Sugar Creek, bass booming as usual. It was a day with seemingly so little significance that it should've just left my brain. But that's when I saw _him_.

I pulled on the door and entered, signaling a faint bell. I could hear the sound of the hazelnut coffee being brewed, the scent swirling around me. He was standing over the register facing me. Watching me.

His dark, watchful eyes followed me from behind the counter as I walked around the store. I was strutting around in a tight new outfit, showing off my curves and sun-kissed skin. I had recently cut my hair super short and sassy. It was vibrant red and blond. I looked good, and I knew it.

I caught him staring at me in the giant round mirror at top left corner of the store. To my surprise, when our eyes met, he didn't look away. I should've been disgusted by his blatant gawking, but I was flattered. I felt challenged. I had a boyfriend, but it felt good to know that I still had it.

As I approached the counter, he didn't break eye contact. His eyes were dark, powerful, and intrusive. Jared had the kind of eye contact that gave you shivers. A look so hot and so cold at the same time.

I'd managed to pick up some ranch-flavored sunflower seeds and a few Arizona iced teas. I looked him in his eyes and confidently said, "I'll take a grape blunt."

At this point he had yet to break eye contact. *Okay, weirdo, what the fuck?* I nodded at the counter behind him, and he slowly picked up a grape blunt.

He asked accusingly, "Now just what do you plan on doing with this?" I rolled my eyes, took a small step back with one foot, and gave him a bitchy look. Clearly no one actually smoked these things.

"I need to see your ID."

I handed it to him, and he studied it a little too long. No doubt now that he was memorizing my info.

"Nice coat," he said with a laugh.

The stupidity of it caught me off guard, and I let a laugh slip through. "Oh, whateverrrr."

In my ID photo, I was wearing a fluorescent orange coat. I was sixteen; give me a break, man. He was smirking, which I wanted to smack him for, but also I kind of liked it. I asked him how much I owed, threw down the money, and left.

I could feel his eyes piercing my backside as I walked away. It made me feel powerful, and I made sure to give him a show.

Wow, I thought, *he's such a creep.*

But for some reason I'll never understand, I not only fed into it, but I couldn't stop thinking about him. Maybe it was all the attention I wasn't getting at home; maybe it was desperation.

That night, as I dozed off next to an inebriated boyfriend, I could see his face. His short, dark, buzzed-off hair, his deep, dark brown, almost black eyes, his black shirt with the red collar. His stupid fucking self-important laugh. This guy clearly felt he had some sort of chance with me, and while I was appalled, I found myself wondering who he was.

As Stella and I prepared to drive around the next day, I was secretly hoping we'd stop by Sugar Creek again. It was on the same street as her apartment, so it wasn't much of a reach. Initially I didn't tell her about my attraction to the mystery man. I mean, I had a boyfriend! If I started talking about it, that would just make the attraction real.

I did tell her that I was ready to quit that shithole we worked at. She wanted to quit too; we were both so miserable. So we lit a blunt and laughed about it. I got a little too stoned that day and came up with the horrible idea of applying at Sugar Creek. Hey, it was only half a street down from my current job.

As we pulled into the parking lot, my stoned heart was having palpitations. I opened the door, and there he stood. I felt as if my heart would burst through my chest any second. *Play it cool, Jess.*

I grabbed my usual snacks and approached the counter. I stated confidently, "I'd like to pay for these and get an application."

"An application for...?"

"To work here."

He smirked and cocked his head to the side a bit, looking impressed by the demand.

I sat at a table in the back corner of the store, the spot where a cardboard junkie typically sat scratching their addiction away. With the scratch-off flecks surrounding me, I filled out the application as quickly as I could. My heart was still pounding. Was I sweating?

I had a full awareness that he hadn't taken his eyes off me. Slowly, I walked back to the counter and placed the application down. He looked at me and said, "I'll put in a good word."

I'm sure you will.

To my surprise, a few hours later, when I checked my phone, I had a voice mail from a woman. She identified herself as the manager at Sugar Creek; she'd received my application and was very interested in meeting with me.

I let out a giggle. I was very pleased with myself.

Wait, what the fuck am I doing, I thought. I knew exactly why I put that application in, and I was disgusted with myself. Not disgusted enough not to call her back, though.

The next day I went in for an interview with the manager who'd left the voice mail. I gassed myself up for it to be something formal, when in reality it was just paperwork and discussing job duties. Little did I know I'd already had the job before I arrived. Weird.

I always wondered what exactly he'd told her.

I was in a form-fitting, white-and-blue-striped button-up and tight black slacks. As I sat on a cold folding chair in the boss's office, there was a lull in our conversation. That's when I heard it. The familiar faint boom, boom of bass in the distance. Suddenly it became so loud and present. The whole building vibrated with the sound, and she looked up almost as if she'd been expecting someone. It was some heavy-metal bullshit that any self-respecting Lil Wayne lover couldn't stand. It was completely obnoxious but at the same time got me going.

That's when I heard his voice come from behind me. It brought goose bumps to my exposed neck. He was standing very close, less than two feet behind my chair. He began playfully chatting with her; it was obvious they had a good relationship. I resisted turning around. *Play it cool, girl.*

She introduced me to him, and the man with the face now had a name. Jared.

He flashed me that devious smile once again and said, "Obviously I remember her, I recommended her. Remember?" I could feel the skin on

my face turn pink. It soon was a beaming stoplight of red when she mut-tered the words, "Jared is your assistant manager."

Fuck me.

Any smart girl would've aborted the mission at this point for several reasons. A, my manager knew I was a pothead. B, I was sexually attracted to him. And C, he was clearly attracted to me too. But no, my stupid ass got excited, because I had just found out he'd be training me.

I should've felt like a pile of shit; I *really* should've. But I didn't.

I pranced home that day wearing a smile, excited for my new conquest. I wondered if he'd stopped in because he knew I was there. I was giddy at the idea.

2

At first things were normal at work, just harmless flirtation. Jared let me bring in a CD to listen to during our training shifts instead of the shitty local radio stations. I chose Colbie Caillat, and despite his love for metal and hatred for country, he didn't put up a fight. He introduced me to new things like Aniello's chicken-wing pizza, and I introduced him to a girl who wasn't scared to eat.

We instantly established a strong bond. At first, it was built on friendship, or so I told myself. After training was finished, I became the store closer. He would come by and "help me close" while off the clock, claiming it was dangerous for me to be there alone so late.

Shortly after beginning my job at Sugar Creek, Chris and I were kicked out of his mom's house. We didn't see it coming, so we weren't exactly prepared to move into our own place. As a result, we had to move in with my grandma in Bath, twenty minutes away. I refused to give up my job at my current Sugar Creek for one in Bath.

I didn't care that it was low pay for such a commute. There was zero way I was going to be stranded in that town and be someone who never left. The real driving factor was I felt depressed just thinking of not seeing Jared anymore.

Things with Chris had really dwindled to nothing at this point. There wasn't much holding us together besides the comfort of being in a relationship. Most days the only quality time we spent together was sleeping. Often I started pointless arguments just to push him away. I resented any fun he had, but simultaneously, I didn't care to partake in any of it. He continued serving at the Market Street Brewing Company in Corning, and would habitually play poker with his coworkers afterward. Working, drinking, and playing poker were his main concerns at that time in life.

Sometimes I'd sit on the curb outside the gas station, consumed by the darkness of the unlit parking lot, just waiting for him to arrive. I'd text him to see how long it would be and wouldn't hear back. I had no choice but to simply wait.

In the days before smartphones to occupy my boredom, every minute I spent alone with my thoughts was dangerous to our relationship. I always kept a journal in my bag, and I scribbled away at my hatred for him, getting angrier as the minutes passed.

One night after closing up shop, Jared insisted on waiting with me until Chris arrived. There was a chill in the air, so we climbed inside his Jeep. I actually had to climb; the thing was lifted and quite absurd. He had a DVD player, and we watched an adult cartoon called *Robot Chicken*. It was the stupidest yet funniest thing I'd seen in my life.

As we sat there, he made it clear that he didn't like Chris making me wait in the dark of night, or that Chris didn't respond to my messages.

"What if it was an emergency, Jess? Could you even count on him then?"

I honestly didn't know.

"If Chris cared about you at all, he wouldn't treat you this way," he said (with his own motives).

I loved how much he cared about me. Why couldn't Chris be like that?

Eventually Chris pulled up. Annoyance washed across his face as he watched me climb out of Jared's Jeep. As I got in the passenger's seat, he didn't utter a word. I secretly wished I was still in the Jeep with Jared; instead, I was bound for an awkward car ride. I could tell Chris was suspicious

about the time Jared and I shared, but he didn't care enough to ask. So as usual, we went on like everything was fine.

Days later I was closing up shop, and Jared was helping. Shockingly, Chris arrived on time. He impatiently waited in his car for me, still steaming from losing money at poker.

Jared and I went into the secluded storage room to turn off the lights on the power box and lock the back door. We reached for the lights at the same time, hands touching ever so slightly. Out of sight, in the darkness, an explosion of tension released as he pinned me to the door, kissing me wildly. I didn't stop him.

The moment was brief. My heart palpitations had returned.

"Oh my God," I sighed as I opened the door. "I have to go. Set the security alarm for me?" I managed to whisper as I ducked out of the building.

I stumbled out to the car, trying to act as if nothing had happened, even though it felt like I was a walking ball of fire.

In that moment, I confirmed to myself what I'd known in my heart: things were done with Chris. I'd allowed myself to get emotionally close to another man, led him to think he could make a move on me, and then gave in to that physical temptation. It made me feel sick. Yes, I wanted to end it, but not like this. It wasn't fair to Chris. I owed him more than that.

I didn't know how to drop the hammer, so I continued pushing Chris away. I told him that I wanted to take a break and needed space. Hoping he'd see that I was serious, I offered to sleep on the couch. But I was still friendly with him because I needed transportation to work. The mixed signals I was sending just to convenience me weren't helping him catch the drift.

Chris's suspicions about Jared came to the forefront. He knew, so I no longer hid the time I was spending with Jared, which was incredibly hurtful to Chris.

"You shouldn't care about Chris's feelings," Jared insisted as he pressured me to cut the cord. "He's had more than enough chances, Jess."

Realistically, I couldn't keep my job in Corning without Chris's transportation help. I wanted nothing to do with him, but I selfishly used him anyway.

At that point Jared and I weren't official. We hadn't had sex yet, but there was lots of heavy petting, flirtation, and texting. I was enjoying the "single life" and had been hooking up with my friend Kris now and then too—not that I told Jared at the time.

Yes, I know what you're thinking: fucking a guy with the same name as your ex is beyond strange. Whatever.

Anyway, I was torn in both directions, knowing each of them wanted to date. In my journal, I weighed the pros and cons of a relationship with each of them but was still stuck.

One day Jared caught sight of me and Kris kissing in the parking lot when Stella dropped me off for my shift. He made zero attempts to hide his jealousy. Jared knew he had competition, and he didn't like it.

Soon after, Jared asked me if I'd be willing to spend his birthday with him.

A date! We were going on a date!

Surely Chris wouldn't assist me in getting to and from Corning for this shit. But I really didn't know how I'd be able to get to Corning without his help or pissing him off enough he'd stop giving me rides, so Stella and I formulated a plan: I could crash on her couch after my date so I didn't have rush back.

This all must've been awkward for Stella, playing the middle woman for me, my ex, my new piece, and my other piece—who, if you recall, was her best friend. But I was her other best friend, so despite being stuck between a rock and a hard place, she did me a favor.

To say I was eager to spend what I assumed would be a magical night with Jared would be an understatement. Hours went by in my dated little bedroom at my grandma's. I sat in front of the floor-length mirror, first perfecting my makeup and then my hair. I tried on every item of clothing I owned, and it looked like a bomb had gone off in my closet. I wished I had a blunt to calm my nerves.

Chris swung by the house to get me and take me to Stella's. I'll always remember the look of regret on his face as I got into the passenger seat. There I sat, in his car, on the way to a date with another man. What was wrong with me?

The drive up was like a game of twenty questions. When he dropped me at Stella's doorstep, he was more than suspicious. I often went with Stella after rolling out of bed, and putting no effort into my appearance. No doubt he was wondering why I'd put in so much effort that day. I wanted him to be stupid, but he wasn't.

I went in and nervously chatted with Stella as I texted Jared that I was in town. Soon enough, I heard the familiar boom, boom of his bass. He'd arrived.

I was thankful he'd planned to eat dinner. After all the frantic energy I'd put into getting ready, I'd somehow neglected to eat a damn thing. He took me to Friendly's to eat—mildly disappointing, since I despised the place and everyone inside. But I was with him, so it didn't matter.

The food at dinner was underwhelming, which is typical for restaurants like that. But we sat there entertaining one another for hours anyway. The booths around us must've changed occupants four times over, not that we noticed. I was sarcastic and quick lipped, but he gave it right back. I felt like myself with him. His company and his attention fulfilled me in ways I didn't even know I needed.

Afterward, he guided me across the lot, hand on my lower back. He helped me hop into his unnecessarily raised Jeep and kissed me gently.

"I want to show you something." He gave me a smug smile, shut my door, and circled around the Jeep, walking to the driver's side. My curiosity had been piqued.

Rolling hills surrounded the quaint town of Corning. As we drove over the long bridge toward the town's center, Jared pointed to the large towers atop the hillside. I'd never noticed them before. "That's where we are going," he explained.

We took the Jeep up the bumpy terrain to the top. I was pretty sure we weren't supposed to be up there, but that was part of the adventure. He pulled up to a cleared-out section where electric lines went down the hill in a neatly aligned row. Picture perfect. Sliding the vehicle into park, he turned to me and asked, "You ready?"

I smiled as I opened my door and jumped down.

The lights of the town twinkled below, and the stars twinkled above. Electricity ran through my veins and brought a chill to my skin. I was awestruck by the scene in front of me, but out of the corner of my eye, I could see him watching me. Turning my body toward him, I thanked him and said it was beautiful.

"You look cold," he remarked as he seductively ran his hand along my lower back, grabbing my waist and pulling me close. I put my head into his chest. It felt like it was carved out just for me.

How was I so enthralled with this man? His life was a mystery to me, but I paid no mind. He ran his fingers through my hair and then raised my chin to look into his eyes. Passionately kissing, his body against mine, I had never needed him more. In a matter of seconds, we were in the grass rolling around. My shirt left my skin, and his followed soon after.

Sex on the ground isn't as satisfying as the movies make it seem. But when it's your first time connecting sexually with someone you're incredibly into, it feels like the Fourth of July. We rolled around in the grass for what seemed like hours. After our sexual escapade was over, I laid my head on his chest, looking at the stars above. I synchronized my breathing with his. I could get used to this.

Afterward he dropped me off at Stella's, my hair a goddamned mess. I didn't anticipate it being so awkward going there, but it was. She texted me several times, asking if I was still coming to stay there, but I'd been preoccupied. Shortly after I arrived, she went to bed. Maybe it was the "just had sex" look written all over me, but I think she was disappointed. Despite her dismay, I didn't care. I fell asleep smiling ear to ear.

Jared and I went to the local drive-in the following evening. There's something so nostalgic about that place. As night fell and the previews began, I flashed back to the memory of me as a small girl in the back of my friend's van. I was scared shitless as we watched the 1993 release of *Jurassic Park*. I haven't gone to the drive-in since.

The movie began on the large screen, but the real show was starting in our car. His lips powerfully pressed against mine as our hands began to explore one another's bodies. The windshield fogged over from the passion inside, making the screen no longer visible.

With its usual poor timing, my ringtone pierced the silence of the Jeep. As "Promiscuous Girl," by Nelly Furtado, began, the irony wasn't lost on me. I quickly pulled away from Jared, diverting my attention to its screen. Shit, it was Chris. The awkward elephant in the room returned. I ignored the call, but Jared had already seen it. In my head my relationship with Chris was finished. But clearly he wasn't on the same page. I looked at Jared, searching for the right words.

"I can't hang out with you anymore until you and Chris are *done*," Jared insisted.

Cue the waterworks. I understood, but I was crushed. My feelings for Jared were already intense. He could be "the one." How could I allow myself to lose him now?

Jared awkwardly dropped me off that night, but he didn't keep his word. We began seeing each other on a more frequent basis. One afternoon he invited me to his parents' house, where he lived in the basement. I wasn't ready to meet his parents, but he insisted. His persistence assured me that he was as serious about "us" as I was. I couldn't let him down.

While approaching his home, I felt uneasy. He opened the door, ushering me inside. I quickly gathered he had the picture-perfect family. The interior of the Collins's home could be compared to a catalog. His stunning mother was baking in the kitchen. She appeared far too young and beautiful to have had all these kids.

Mrs. Collins looked up from her creation, wiped her hands, and smiled. I watched as her tiny frame approached us, and she was beaming. "So nice to meet you, Jessica! I've heard so much about you!" she proudly exclaimed before giving me a tight hug. "My name's Beth."

I was welcomed with open arms, literally. Our families couldn't have been more different. Jared showed me around the home, introducing me to his siblings. I wondered what it must be like to be raised in such a flawless family.

As the night ended, I wondered how I would get back to Bath. The last thing I want right now was to face Chris.

"My parents usually wouldn't allow a girl to stay here with me. They're religious." *Of course they are.* "But they seem to like you, because they said

you could. I told them you work early." I wondered how much they would like me if they realized I had another man waiting for me at home.

I messaged Chris, keeping it short and sweet. "Lock up when you get in. I won't be home tonight." Ruthless. He knew I was with Jared. I should have cared more about his feelings, but I didn't.

Chris had reached his breaking point. I could feel the pain through his words. Being with Jared was the ultimate betrayal. I lay there in Jared's bed, exchanging text after text, years of relationship dwindling down to impulsive T9 messages. I couldn't believe this was how it was ending. *Please let me be making the right decision. I don't want to regret this.*

"I'm packing my stuff. I'll be gone by morning," was his last text. And he was.

I didn't dare shed one tear for him in Jared's presence. I wanted this. It was time to shit or get off the pot. All this lying had been tearing me apart; now it could finally be over.

With Chris out of the picture, Grams agreed to help me get to Corning on the days I worked. I appreciated it, but her driving worried me. She was a longtime bus driver, but her skills had gone majorly downhill in the years following retirement. I only let her drive me there during daylight, and even that was pushing it. Thinking of her driving alone back to her house made me nervous.

I made friends with a new hire, Michelle. She was a young mom, my age. Since things had progressed with Jared, hanging out with Stella and Kris just felt weird. I didn't know how to address the Kris situation, so as usual, I avoided it. The time I'd previously spent with Stella was now spent with Michelle.

One day she and I met at the Subway next to our work for a little lunch and a lot of gossip. I was sweating the transportation issue, and I didn't want to quit my job. Michelle offered a solution to my problems: she lived a short walk from the store and said it would be fine if I stayed with her on nights that I closed.

Awesome, now I didn't have to worry about having a ride home, and I'd already be in town for the next day. I was thankful, but I knew it wasn't

a long-term solution. I wondered if Jared would be willing to help, but I didn't want to rock the boat. My pride held me back.

I went to work delighted, knowing I had a few shifts covered until I found a better solution. During my shift, I heard the bell ring on the door, alerting me that someone had entered. I turned to greet the customer and saw it was Chris. Eye roll.

Shit, what did he want? I really didn't want talk to him; we hadn't spoken since he left. We'd exchanged all we needed to say over text. Or at least I had. I wasn't in the mood for talking. Because he refused to help me get to Corning, I was in a bind. I didn't blame him for stopping, but that didn't do me any good!

He went to the back of the store and grabbed a thirty-pack. After paying, he asked, "how have things been?" He looked me up and down. "You look good."

"I'm really not in the mood to talk right now, okay? I've got enough things to worry about."

"You know, we don't have to argue. We can get along. We can be friends."

"I don't think that's going to work for me," I responded with attitude and zero eye contact.

He shook his head in disbelief, grabbed his beer, and left. As he was leaving, I heard the bell ring again. Turning around, I saw Jared. I flashed him a smile. Finally, a good part of my day...only he wasn't reciprocating the smile. The store was empty, and he used that to his advantage to let me have it.

"Do you think this is funny? Is this a fucking game to you? I'm coming here to surprise you and you've got your ex in here doing God knows what? You whore."

I was completely taken back. I'd never seen this side of him. Why was he saying these things? The water in my eyes welled up.

"I can't control other people's actions. I can only control mine. I told Chris I didn't want to even be friends. You have to believe me!"

I pleaded and pleaded for forgiveness for something I hadn't done. He didn't say anything in return. He just stood there, fists clenched, lips

pursed, staring at me. The silence was a killer. A car pulled up to the building, and Jared stormed away to the office, slamming the door behind him.

What the fuck?

Eventually he calmed down, but he didn't apologize for his words. When he drove me home, we talked as if everything was normal. Oh well, at least I was back on his good side. What would I do if he left me? I loved him.

In the coming weeks, Jared insisted on being my ride home. Driving in the dead of night back to Bath, we'd hold hands, the heavy metal bumping on the sound system, vibrating every piece of his Jeep. He'd drive me twenty minutes to Bath, just to drive back to Corning. He had to be up early for his six o'clock opening shift. I felt bad about it, but he was the one who insisted on doing it. Selfishly, it felt good to have someone put my needs ahead of theirs. At first things were good—too good. I was young and in love, falling like Alice down the hole.

3

There are two types of grandmas, I've learned: ones who coddle you, and ones who will tell you exactly how it is. My grandma was a widow, white hair and fragile by appearance, but make no mistake, she was anything but weak. She was a spitfire, and she never held back an opinion that needed to be heard. Back then she lived on a cigarette–and–Black Velvet diet. She made zero apologies for who she was, nor should she have.

My breakup with Chris crushed Grams more than me. "You girls change your boyfriends like you change your underwear," she said, despite my dating only Chris for several years.

She acts like I'm out banging the whole town, I thought. *How irritating. I'm not even in my twenties. Why should I settle with someone forever if I'm unhappy? She does realize this isn't 1912, right?*

"Why would you leave a kind man with a bright future for no reason?" she asked.

"I just didn't love him anymore, Grams," I answered.

She lit a cigarette, took a drag, and rolled her eyes. "Oh my heavens! You don't even know what love is."

She'll get over it. I don't care what she or anyone else thinks.

Despite Gram deserving all the respect in the world, I didn't always award her with it. Jared would drive me home after work, and since we

were already getting physical, I saw no issue in having him stay the night with me. Usually he'd leave early in the morning for his work shift, no doubt awkwardly crossing paths with Grams in the kitchen. I lacked the respect to even ask her if this was okay.

She'd never been introduced to him, since she was dead asleep by the time I got out of work. I can just picture her now, sitting at the table with her morning black coffee, cigarette smoke swirling around her whitish-yellow-stained hair, reading the daily paper, when a strange man appears from my bedroom's direction. I'd have paid to see her face. What was that encounter like?

I participated in that bad habit a few weeks before she caught up with me. She cornered us in the kitchen one morning, coffee in hand, and said, "Are you actually going introduce me to this man that you've decided can stay in my house? He could be a felon for all I know!"

Here we go.

"Grams, this is Jared, Jared, this is Grams. We good now?"

"So...Jared, what is it you do for work?" she questioned.

Oh hell. It was too early for this. Chris was a computer programmer, and no doubt Grams was making this a contest.

"I'm the manager at the Sugar Creek where Jess works," answered Jared.

She chuckled, sipped her coffee, and asked, "Is that it?"

I wanted to die. "Grandma!" I yelled.

Jared responded, "No, I'm actually a volunteer firefighter as well."

My forehead involuntarily scrunched, and my eyes squinted as I looked in his direction. What? Firefighter? First I'd heard of it...How much did I even know this man?

"Volunteer?" Grams snorted. "So just to be clear, Jess, that means he doesn't get paid."

Oh my God.

"Well, that's more than enough of that rudeness. We're leaving," I told Grams.

"*I'm* rude? You're the one using my home as a hotel for your conquests to come and go as they please. But right, I'm the rude one!"

I was embarrassed and angry, but points were made.

"You let Chris live here without issue. Suddenly I'm supposed to be celibate? Come on!"

"You can bring home whomever you want. But as long as it's in my home, young lady, I'll be charging you like it's a hotel."

"Ha, ha, Grams, very funny." But she was dead serious.

"I'll give it to you for a discount. Sixty dollars a night."

"You can't be serious!"

She was.

"Fine then! I'll get my own apartment. I don't need to live here!"

"Fine!" she yelled as pushed Jared out, slamming the door behind me.

Sitting in the passenger seat, I wanted to wither away and die to avoid what had occurred. Jared decided to break the silence.

"It's an appropriate choice to get away from your clearly crazy family anyway. You should move to Corning to be closer to me."

I was unsure why he was saying this about my family with one interaction under his belt, but the second part of the statement overshadowed the first. He wanted me to be closer to him? I looked at him and smiled. He looked at me, and I saw anger brewing underneath. I sat in silence, not wanting to poke the bear. We weren't even officially dating yet; I didn't want to have our second fight.

"I'm sick of fucking driving you back every night anyway. Do you have any idea how inconvenient that is for me, and a waste of my time? I can't believe you expect me to do this!" he burst out.

I paused for a moment in confusion and hurt, deciding how to respond.

"I'm sorry, Jared. I assumed you didn't mind. When Chris stopped driving me, you insisted that you'd..."

"*Don't* you ever speak his name to me again!" he exploded.

I glanced at the speedometer as he accelerated, nearing eighty miles per hour. He'd taken the back way to Corning; its speed limit was fifty-five.

"Jared, please slow down. You're scaring me!"

"Not until you apologize for what you said."

Again I apologized for something I didn't do.

Red flags were waving, but my feelings obscured my view. I silently sat looking out the window the remainder of the drive, holding back the tears welling in my eyes.

As days went on, I saw a change in Jared. In the beginning he was everything a girl could've wanted. He was at my beck and call, complimenting me at every turn, affectionate, and always there to talk. If I could write a list of attributes for my dream husband, he would've checked off each one. But slowly...things changed.

"I feel like he does things just to keep me on my toes," I told Michelle.

"What do you mean?"

"I don't know. It's probably just all in my head." It wasn't. He'd go hours without acknowledging my texts. In panic, I'd send seven more. I didn't know how to respond to the change.

When I acknowledged that I felt he was being distant, he claimed it was because of work. I worked there too, and didn't notice any difference in the place. I tried believing him, since I didn't have a reason not to trust him. Still, I was sad. Something about it rubbed me wrong.

Seeing I was hurting, he asked, "Keep tomorrow open for me okay? I'll come down and we can spend the whole day together."

I woke up early, cleaned my room, and made myself look perfect. With butterflies brewing, I lay on my bed with anticipation. For hours, sounds of Colbie Caillat repeatedly vibrated through my ears while I stared at the ceiling. The CD cycled around again. Where was he?

I checked my phone like an addict waiting for her next fix. I texted multiple times, but not too many. I didn't want to come across as too needy. I looked at the clock. I scrolled through our recent messages, analyzing them. My texts were long and meaningful; his were short and infrequent.

I suddenly became aware of the pit forming in my stomach. He'd been pulling away, and I'd been too stupid and smitten to tell. At eleven p.m. I grabbed my journal to vent.

He's so distant, I wrote. *I don't know why I put my feelings out so far on the limb. No one seems to care. I'm sick of him not responding to messages. He's amazing when we're together, but when we aren't, he's kind of disappointing. He never texts first, and never responds even though he knows it bothers me. But I know that's just how boyfriends are.*

I was already making excuses for him.

The next day, still dressed in the clothes from the day before, I awoke to a ding on my phone. I pulled open my bloodshot eyes and grabbed the

phone from my pillow. "New Text Message" the screen read. I flipped it open. *Finally.* Maybe he was messaging me to apologize.

"Hey!!" the message read. And that was it.

I could feel my blood begin to heat, and soon enough it would boil over. I grabbed my journal and began scribbling with fury.

FUCK GUYS. They're so dead to me. I stayed up all night, crying in bed. He didn't return any of my texts yesterday, or answer my three calls. This morning he doesn't text me sorry or an explanation, but "Hey!!" After a month together, this is what I get? Maybe I'm just wasting my time!

I talked with some of the girls at work to get their feelings on the situation. They agreed that he'd fucked up and owed me an apology. Damn right he did.

He met me at Sugar Creek to take me out to lunch. My feelings were written all over my face. At first, I wanted to slap him, but eventually I let it go. Just another thing slid under the table. In typical Jared fashion, he tried to make me laugh, continuously deflecting the conversation toward anything but his actions.

What he said next took a turn for the worse. He informed me that our Sugar Creek was not making enough profit, so the owners were closing their doors.

I began to panic. What? Was I losing my job right now?

Jared clarified other stores in the area were short on employees, so we would be transferred to the most appropriate ones. Given my address on file stated Bath was my hometown, that was the store they wished to transfer me to.

"Absolutely not!" I said. "You have to tell them that I'm moving to Corning, and I need to remain employed there."

He said that he would talk to the general manager, and he was sure that wouldn't be a problem.

"Where will you go?" I asked with hesitation.

"They've asked me to manage the store in Addison. It's a promotion for me. I have to take it."

I wore a poker face, but I was devastated. Our work reign together was coming to a close, and I was nervous that meant we would be coming to

a close as well. Would he start a new work flirtationship? I was jealous at the thought.

Jared asked me if I would stay with him that night. In my cloudy mind, that made up for things. I was finally getting his attention, which was all I wanted from the start.

My eighteenth birthday was creeping up that Sunday, and my sister Sam insisted on throwing me a party at her place the night before. I begged Jared to come. I was so desperate to have a normal relationship with him. He told me he'd make it; he promised. I was over the moon that he was willing to meet some of my friends and family.

Saturday arrived, and Jell-O shots were had. From the start I had my lips wrapped around a handle of Captain Morgan. Each hour that went by without Jared's arrival, I drank more heavily. With each sip, my hopes became cloudier. He couldn't do this to me again on my birthday, right? My friends insisted he would show. But they didn't know him. Hell, did I even know him?

Late into the night, he still hadn't arrived. The handle was almost gone, and my alcohol was finally catching up to me. I was a raging puke monster in the bathroom, with my sister holding back my hair.

Sam interrupted. "Ugh, Jess. He just messaged you. He's almost here."

I groggily pulled my head out of the toilet. *Fuck.* I didn't want him to see me like this. Ugh, seriously, three a.m.? I was too inebriated to argue.

"Meet me outside. It's late, and you need to go home!" his next text read. Little did I realize it was a demand, not a request.

"Come inside, babe," I responded.

He immediately called me. "You're embarrassing the both of us! What makes you think I want to meet your wasted friends? Get outside *now*," he grunted as he hung up.

Jeez. I said a quick goodbye, thanked Sam for all the fun, and snuck past everyone to leave.

As I got into the Jeep, I could tell the energy wasn't pleasant. I made sure to be on my best behavior to avoid saying something upsetting. Once I got home, he guided me to my room as I bumped from wall to wall down

the hallway. I was thankful both that the party was over and that Grams wasn't awake yet.

I tried to fall asleep, but he insisted on giving me a "birthday gift." I told him I wasn't feeling well, but that didn't stop him from tugging off my clothes while I batted his hands away. He'd always talked about doing anal, and I often joked "maybe if I was drunk." He felt this was the opportune time, despite the fact that I could hardly stand.

"Jess, after getting this drunk and making me take care of you, you owe me."

Oh, poor him. He'd only been with me a whole ten minutes! "Please just let me go to bed," I pleaded.

"You talk a big game, you know. Always playing with me when you know I want it. It's about time you followed through with your claims."

Face into a tear-soaked pillow, I lay there in silence as he had his way with me. I begged him to be gentle. He wasn't.

My alarm rang, and I awoke with a pounding head and a sore ass. I felt naked in a new way. I was ashamed, not to mention embarrassed. Not because of my intoxication, but for not standing my ground and for allowing myself to be defiled. I felt like a discarded piece of trash that kept being stepped on. Left with each passerby's filth. I felt dirty. I felt useless. I felt used.

I slowly turned over to face the devil on my right. He was awake, smiling of course.

"So last night was awesome, right?"

I couldn't believe the monumental disconnect. But like a good girlfriend, I lied. It was coming to light that Jared was more aggressive than I could've ever imagined. I tried to slip the flashes of memories from that night into the back of my mind. Maybe if I buried it deep enough, I could forget. It would be as if it never happened. But as I carefully wiped the blood from my ass in agonizing pain, I knew I would never forget.

4

September 23 was the day, my birthday. I confidently opened the Sunday paper to the classifieds, trying to block out last night's events, and sat down with Grams at the kitchen table.

"What a simply terrible idea this is," she voiced, sipping her coffee. "I wish you'd stay just a little longer, at least until you're more on your feet."

And because I was stupid, I disagreed.

At that point I was only raking in about $600 a month working at the gas station. Six hundred dollars is practically baller status when you live with your gram. A couple of affordable apartments were in the paper, so I formulated a list. Picking up the phone, I called each one. Landlords asked me questions about how old I was, where I worked, and my past rental experience. None were interested in renting to me.

I kept up the search for weeks and weeks, saving money in the meantime. Finally, I saw a studio apartment listed for $315, utilities not included. Of course, this was "in my price range," so I called the landlord to set up a time to meet. Luckily it was still available, and he agreed to meet with my parents present.

Thankfully, they agreed to accompany me. I decided I was going to sign the contract before even looking at the apartment, but due to my age, it was required that one of them cosign. I had enough saved

for the first month's rent and security deposit, so Mom didn't hesitate. Excitement ran though me, and I felt big things were coming my way. I was wrongly confident.

Grams was less than thrilled when I got home and dangled the keys in her face.

She asked questions I didn't have answers to. I couldn't recall any details about the apartment. Was there a microwave? Were there sufficient outlets? Was it wallpapered or painted? Were there ceiling lights, or did I need to use lamps? Was there a shower and a bath? How was the storage and closet space? Was garbage included?

The answers to these questions were unimportant to me. I was clueless but thrilled nonetheless. I went to a local Family Dollar and spent money on cheap silverware, an adorable plate set, and nothing of real significance. I bought some canned food and frozen meals to stretch my dollar. Because responsible adults stretch dollars.

My parents drove me to my new town, Corning, where everyone was virtually a stranger. They helped me move my belongings, which were laughably minimal. Jared claimed he'd help move me in, but I didn't hold my breath. As the afternoon dwindled and my parents prepared to leave, I could tell they were nervous. But I knew I'd be just fine. I reminded them I had a boyfriend only a few blocks away. I don't think his current absence helped.

Once they left, I let out a sigh of relief. I was finally an adult. How cool was this?

The sun began to set, and the apartment darkened. In this moment I realized why Gram had asked the question about lights. It was dark, but thankfully Gram had given me a lamp. I swore it wasn't necessary, but she insisted I go up into her creepy attic to find it. *Good call, Grams.*

By the dim light of a small lamp, I decided to unpack and find a home for my shit. I dragged my garbage bags full of clothes to my closet, then quickly realized I had no hangers. No dresser either. Sigh. I folded the clothes and arranged them in piles on the closet floor. Smiling to myself, I shut the door.

I stood in the middle of the empty bedroom, hands on hips, assessing it. I began unpacking my bedding and pillows and placed them on the floor in the corner of the room. The floor would have to do for now, but it wouldn't be long before I got a bed. Because really, how expensive could they be?

I was feeling very fortunate that I'd kept my alarm clock/stereo combo that my parents bought me in high school. I popped open the CD door and placed an old scratched-up Shania album inside. Dancing around my new kitchen, which was also the living room, I decided to put together dinner. Raviolis sounded good.

I pulled the can of raviolis and a bowl out of the cupboard. Panic soon hit at the realization I had no can opener. "Are you fucking serious right now?" I muttered to myself. I added that to my "to-buy list," which was seemingly multiplying by the minute.

Well, canned goods were out. I pulled down a box of Kraft mac and cheese. Milk? Butter? Ha. I didn't buy those. They seemed expensive. Not to mention I'd also forgotten measuring cups. Okay. Well, plain macaroni would have to do for tonight. Thank God I'd bought a pot and pan set.

I hadn't bought any utensils like spatulas, so stirring with a small metal spoon would have to suffice. I again started to panic when I discovered I didn't have a strainer. In my panicking I overcooked the noodles. *Yay.*

The answer to my problem was putting the lid on the pot in an attempt to strain it. I did this without pot holders, of course, because who remembers those? The steam burned my hand, and I dropped half the noodles down the drain. I yelled out some obscenities for good measure. Salvaging what I could of my mush noodles, I figured I'd at least sprinkle some salt and pepper, but of course I'd forgotten them too.

Sitting on my cold linoleum floor in my empty kitchen, I ate my first glamorous meal. I stared at the empty spot next to the wall that would, I hoped, eventually be home to a small table. I glanced at the list I'd quickly created of things I needed to purchase. In this moment I felt terribly defeated, and the tears began to roll.

Need to buy:
- Lamps and light bulbs

- Hangers
- Dresser
- Bed
- Can opener
- Measuring cups
- Spatula
- Strainer
- Pot holders
- Salt and pepper
- Kitchen table and chairs

It had taken me until that very second to be appreciative of my parents. I felt terrible for everything I'd used, never paying attention to cost. I'd taken for granted always having toilet paper to wipe my ass, and condiments that always seemed to just be there. We didn't always have everything that we wanted, but we certainly had everything we needed.

I messaged Jared, hoping he would show or at least provide a message of comfort. As usual, I didn't receive anything.

Days went by ever so slowly in my empty apartment. I felt so alone. Every day like clockwork, I'd break down, wanting to call Grams for help. But I could never bring myself to press send on my phone. I had said I could do this on my own.

We'd talk often, and she'd always ask how I was doing and if I needed anything. Each time I lied.

Purchasing necessities at the Family Dollar across from work became a luxurious shopping trip. But as time went by, things slowly improved.

As the leaves on the surrounding trees grew crisp and dry, the air turned to a bitter cold. Soon enough winter reared its ugly face, and I found myself cranking the thermostat. Creaky old houses didn't provide much warmth from New York's wintertime cold. And don't get me started on the freezing pipes.

On a snowy winter night, I hurried home from work. Clunking through endless yet-to-be shoveled sidewalks in snow-soaked boots, I reached home to find a bill peeping out of my mailbox. Two hundred sixty dollars for gas? That *had* to be a mistake. It wasn't.

I shut off my thermostat, poured a hot bath, and sobbed till the water turned cold. I only had $285 after rent...and I still had other bills to pay, plus food, et cetera. How could I survive?

Every dollar in my savings would have to be drained just to pay that bill. But it had to be done. I wouldn't be able to afford Christmas gifts for anyone, but I didn't have a choice.

I felt so beaten down. I'd been living there for months, sleeping on the floor, eating like shit—and very little at that—just to put some money away to buy a bed. It turned out those were astronomically more expensive than I realized. It would be months before I was able to build up my savings again.

To make matters worse, Jared would come and go as he pleased. Always on his terms, never on mine. I only saw him when he needed something, usually a piece of ass. Then it was the disappearing act all over again. I was dating a ghost. He never offered to help, which was little surprise to me.

One night his mom invited me over for dinner. During conversation with her, in pure frustration, I vented about the bed situation and gas bill. Beth was upset to hear I'd been sleeping on the floor this whole time. Immediately she offered the family's air mattress until I could afford a proper bed. I was thankful for her kindness but also embarrassed to be struggling.

Unfortunately, the mattress wouldn't stay inflated through the night. But hey, it was better than nothing. Each day I awoke on the floor with it deflated beneath me.

I'll make it through this month, and life will turn around.

As the end of the month neared, I went in to work my usual shift. Entering the office, I glanced at the schedule to jot down my shifts in my planner. I thought my eyes must be failing me. Surely this couldn't be right. This couldn't be happening! My hours were cut.

"Did I do something wrong?" I asked my manager as soon as she picked up my call.

"Calm down, hon. You didn't. Corporate called yesterday and insisted I trim hours at the store because profits are down. I'm sorry, but since you're the newest employee, yours had to be cut first," she explained.

"I understand," I managed to mutter as I ended the call. How was I supposed to survive on this?

That night I sat down on my "living room" floor with my bills in front of me and decided to make a budget. *Grams taught me how to balance a checkbook and make a budget. I've got this.* Three hundred fifteen dollars for rent, one hundred for gas, sixty for electricity. Four hundred and seventy-five dollars. The month had four paychecks, so I had to put aside $119 each week to make it.

The first check came. It was $125. I had sixty dollars, an empty fridge, and absolutely had to do laundry. Beth insisted I do laundry at their house. She clearly could tell I was struggling, but she was kind enough not to make it a thing. Because of her charitable gesture, I'd be able to eat that week.

I bought a loaf of the cheapest white bread I could find and some dollar-store peanut butter. I figured I could just ration myself one peanut butter sandwich a day. But Lord knows Jared would cut into that.

On days I worked, I could eat the leftover pizza that was meant to be thrown out. It was unsuitable for sale after so many hours in the warmer. Sometimes it would get close to the cutoff time, and I'd just stare at the last rotating slice, praying no one would come and buy it.

For months I survived on stale "garbage pizza," expired Oreo Cakesters that were on sale for fifty cents, and ninety-nine-cent warm, salted cashews. Occasionally, I would be invited to the Collins's for a home-cooked meal. Those were the best days.

Every once in a while, someone wouldn't return for their change when they prepaid for gas. Whether it was forgetfulness or laziness, I didn't know. At the end of the shift, sometimes it would amount to one dollar or more. I'd take it, even though I wasn't supposed to. Why should the gas station keep it? I certainly needed the money more than they did, and in my eyes, it wasn't theft if the customer didn't use that money to purchase goods.

One week, after a paycheck where I'd only had a whopping twenty-five cents left after bills, a girl prepaid with a twenty-dollar bill and *never pumped her gas*. I took that shit home, but I sat on it a week before spending

it in case she returned. She was either embarrassed or oblivious, because she never did.

That twenty dollars was a huge help. I bought a box of ramen, bread, spaghetti, and some pasta sauce. My cupboards had never been so full. Finally, I was living like the royalty I was meant to be.

With little income and no food in the pantry, I should've been skinny as a rail. Quite the opposite was occurring, as apparently a food pyramid of pizza, salted peanuts, and Oreo Cakesters doesn't give you a six-pack. My body was storing away any "nutrients" I gave it as fat, because Lord knew when I'd eat again.

I was getting chubby, and Jared couldn't go a day without poking fun at my softness, or literally poking it. He'd go to the cupboard to get the last package of my off-brand Pop-Tarts, and even though he'd eaten the entire box, he'd comment, "Last pack? You're such a piggy." Piggy. His favorite insult.

One morning when I wasn't working, I got a call from my parents. They were driving to the Walmart in town and wanted to stop by. When I left town with Chris, I'd still seen them quite often. Moving to Corning without transportation essentially cut me off from them and everyone else entirely.

I held back happy tears when they arrived. I think my parents were stunned when they found I still was living with virtually nothing, despite the months that had passed. They didn't make a big scene about it, but the next day something special happened.

My parents came with my friend Anthony's parents in tow to drop off some extra furniture they had around their house. They dropped off a floral love seat, a large kitchen table with chairs, a wicker rocking chair, and a round end table. My parents even brought my futon that was still sitting at their house. Why I didn't ask for it sooner was beyond me. Pride, I guess.

After months of living in my apartment, I fell asleep on my futon for my first peaceful night's sleep. The next morning when I woke up, I felt glorious. My back thanked me for not waking up on the floor for once.

"I have the most amazing people in my life," I said, and I beamed as I got ready for the day. I couldn't believe it. Maybe my life was finally looking up.

5

The sentiment didn't last long. Living alone didn't quite provide all the warm fuzzy feelings I assumed it would. I had nothing to do to pass the time. I knew no one in town other than Jared. Hell, I didn't even have a TV or computer. And let me remind you, this was pre-smartphone days.

Rarely, I'd get to Bath to see my family, but those were days I looked forward to. One night a friend picked me up so I could stay with my sister Sam. We decided to eat at a Chinese buffet in Corning before having some people over at her place for drinks. I hoped that Jared would join us for food and meet my sister, but he just came up with excuses as usual. I was massively disappointed but not shocked in the least bit. I was used to being let down.

I vented to my sister, and in return she responded by letting me have it. These were the days of Myspace, and certain things were a big deal. She'd been stalking his page for me, since I didn't have the means to, and she noticed his relationship status still read "single."

Hurtful.

Also, a girl named Erin was in his Top Eight, which he'd recently edited, but I was still nowhere to be found. She'd recently written "I love you" in a comment on his page as well. Sam demanded to know more about their relationship.

I didn't know what to say. Jared kept our relationship and his friend-ships completely separate. I knew little about them, and likely they knew nothing about me. I'd asked to meet them, but he was against it, claim-ing an ex "took over his group of friends" after a breakup in the past. I pushed the subject on multiple occasions, but the more I pushed, the angrier he'd become.

I'd recently caught wind that he'd picked Erin up when she was drunk, around the same time as the "I love you" comment. According to his story, she'd been drunk driving and sideswiped a car. I didn't mind that he was being a good friend, or that she was drunk at the time; rather, it made me uncomfortable because he no longer came to my beck and call. He told me I was insecure and jealous. I just wanted the same attention he could afford to pay others.

Jared also forbade me to write on his Myspace page, because in his words, "people don't need to know our business." Additionally, he'd insisted that I change my relationship status in front of him, but he wouldn't reciprocate since he "rarely got online." That was a blatant lie; he was on daily.

Sam pointed out the red flags waving, but I had an excuse for every-thing. I always came to his rescue, but truth was, I doubted it all myself. I claimed Erin wasn't even attractive, which, even if it were true, I knew meant nothing. I told myself it wasn't a big deal that he'd helped her move her apartment but didn't help me. I told myself that I still mattered, despite all the times he showed me different.

One secret I kept from Sam was I'd found out he'd gone on a nine-mile hike with another girl. A new "work friend." To put it kindly, Jared wasn't an active person, and certainly not a nine-mile hiker. I'd once sug-gested that we walk around the block every night after dinner to trim a few pounds, since he was always nagging me about my weight gain. He refused and stated that he hated walking. Yeah, okay.

But the night I was at my sister's, I'd had a lot to drink. I sat at her com-puter in the dark, wildly typing up an email. It began with me pointing out all the red flags and ended with me excusing them all. I'd come to a circle

in my email, and I don't even know the point I was trying to make. I was hoping that he'd at least acknowledge my feelings.

He didn't even respond.

I wasn't permitted to ask him any questions regarding his suspicious activities. If I asked in person, he would lose his shit, then leave. If I asked him through message, he'd simply ignore me until I messaged him about a different topic. He just liked to keep his friendships private, I tried to reassure myself.

But living alone with plenty of spare time provided me ample opportunities to overthink every one of these situations. I couldn't let them go when I'd see him. He'd get heated over the accusations and tell me I had insecurities to work through. I knew he was right, but was he using that to his benefit? Instead of addressing my issues with him, he'd turn it around.

"I find it suspicious how late you were sending emails that night. Why were you up drinking so late? Who was there?" His accusations seemingly never ended, so I eventually dropped the subject to save myself some sanity.

As days went by, I noticed that he was changing, and not for the better. All those little things that drew me near had disappeared. I'd believed he was into me, but maybe it was my imagination. After two weeks feeling like I was living in a mental prison, I didn't know what to do. I couldn't eat or sleep, but I still couldn't let him go. "I can't live without him," I'd convinced myself.

He'd break up with me multiple times a week, for no reason. One time I told him I was done, to see if he'd come running back like I did. I was left in disappointment, as he didn't reach out. He didn't care. So I went crawling back, begging for forgiveness.

At times I'd pray for a text back; other times I'd wish he wouldn't. His messages were often incredibly hurtful and mentally abusive. I took to my journal to vent:

Why doesn't God want me to be happy? Everyone else gets happiness and I get nothing. I can't take it anymore. I refuse to live an unhappy life. I'll kill myself before I do that. I can't even be myself around him. Everything I say and do

offends him or pisses him off. I'm tired of walking on eggshells. He makes me cry every day and doesn't even say he's sorry.

I was once a strong woman, but that woman was decaying to nothing. Everything I once loved about myself annoyed him to the core, and he made no effort to hold that back. He was my drug, slowly killing me. But he was also my only thing worth living for. I'd blow up his phone begging him to come stay with me. I couldn't take the quiet. I couldn't take being alone. But the pleading was useless.

I rashly asked him to move in with me, thinking if we put our money together, furnishing the apartment would become affordable.

"I won't stay with you until you stop being lazy and get a bed," was his response.

Like it was that easy to pull money out of my ass. Of course, he'd only allow me to stay with him when he felt like it. He was hot and cold. His warmth was unpredictable and short, like the first unusually hot spring day.

Just when I'd think things had gone too far and nothing was worth holding onto, he'd reel me back in. "Focus more on you and not him," I'd scold myself. I wrote a list of goals and placed it on my fridge as a reminder.

One day after raiding my fridge, he yelled into the bedroom, "Want me to help you with parking and your K-turn?"

"Huh?"

"You know, to get your license?"

I was shocked he was offering to teach me how to drive. I agreed to his offer, mostly for one-on-one time, and to my surprise he was kind and patient in his lessons. We laughed together like the old times, and it gave me just enough hope to keep going.

6

Our relationship was like a road trip through mountains. The lows were low and long, the highs beautiful yet temporary. The anticipation of the next summit was the driving force. When things were bad, I'd remind myself, "This too shall pass." It had to.

Sometimes I'd hear buzzing in conversation about upcoming family events, internally wishing to be invited. His mother knew not to press it, even if she wanted me there. They'd been discussing his grandfather's retirement party for a while. I'd met his grandfather several times, and he seemed to take quite the liking to me. I sincerely hoped to be invited.

Finally, Jared obliged.

I was on my best behavior that night, eager to please his family. For the first time since we'd met, Jared indulged in a few drinks. I was nervous as I watched him throw back one Jack and Coke after another. To my surprise, he wasn't aggressive. Maybe he wasn't the monster I made him out to be in my head. How could I be so in love and so scared of someone at the same time?

He begged me to slow dance to "Teardrops on My Guitar," and the romantic girl inside me swooned. He gently whispered the lyrics as he spun me around, dipping me now and then. His whole family watched on. I fantasized about dancing with him at our wedding. It was a moment of

magic, and I didn't want it to end. Just like that, I remembered why I fell for him in the first place.

■ ■ ■

We'd been getting along well for a week or so, which was a miracle by our terms. That night we had plans to meet his brother Elliot at Sorges for their all-you-can-eat pasta night. Elliot was running late and told us not to wait on him to order. Jared chose the seat against the wall, so I sat with my back to the room. As I ate my plate of lasagna, I couldn't help but notice he kept glancing over my shoulder at this young single mom and child.

Normally I'd find it cute, maybe get a glimpse of baby fever even. Call it intuition, but I knew something was off.

Elliot arrived a short time later and took the seat between us, striking up conversation. I always enjoyed hanging out with Elliot; he brought laughter to an otherwise dull exchange. At first, he didn't see her. But when she got up, preparing her child to leave, Elliot began to change his tune.

Turning to Jared, he asked, "Did you see that was Ashley?"

"Yes," Jared grunted.

"Well, did you go talk to her and your kid? You didn't ignore her, did you?"

While simultaneously rolling his eyes, Jared boomed, "It's none of your business! Now shut up, Elliot!"

"Whoa, whoa. Someone care to tell me what's going on? Who the hell is Ashley? And what child?" I fumed.

Elliot pushed back his chair and replied, "This is unbelievable, even for you Jared."

Before I knew it, Elliot left without paying, and Jared and I sat there in awkward silence. He threw money on the table and demanded for me to get up.

What. The. Fuck.

And that, my friends, is how I found out my boyfriend had a baby that he didn't take care of. As I looked at him, every part of the man I knew

was quickly fading away, a monster left in his place. I questioned if he paid child support, and he admitted he didn't. He refused to elaborate on the details, but he insisted her child likely wasn't his. He used the familiar excuse that she'd "slept around" on him anyway, so why should he pay? Of course, he refused to get a DNA test, that would just be absurd.

"Listen, Jess, she's a slut. There is zero chance that thing is mine. I'm not paying for a pointless DNA test."

"You don't know that, Jared. One plus two equals baby, in case you weren't aware how that works."

He made it clear I wasn't to question him about the situation ever again.

I was having a hard time coming to terms with it all. How could he withhold something so life altering from me? Yet he acted like it was nothing. Was he embarrassed by his lack of effort? Did he truly believe the child wasn't his? I couldn't come up with a single reason that was good enough to excuse this monumental white elephant in the room. Maybe he'd never shared his secret because he didn't feel we were serious.

"What else is he lying to me about?" I pondered. And I would soon find out.

■ ■ ■

I'd been working at a different location in town since moving to Corning; Jared had fulfilled his promise of speaking to the general manager for me. Luckily the store I'd transferred to was only a few blocks away from my apartment. At my new store, a pregnant woman would come in like clockwork. Even though I didn't know her, I felt she hated me. I could feel the negative energy each time she walked through the door. One day it suddenly became crystal clear.

Like I did for any normal transaction, I scanned her soda and chips, asking, "Anything else?" Instead of reaching for her wallet, she just stood there staring at me with her arms crossed. Peering into my soul.

"Are you Jessica?"

I glanced at my missing name tag in confusion. "Ummm, yes? Why do you ask?"

She pulled back her cardigan, ensuring I saw her newly exposed, protruding stomach. "And you're dating Jared, correct?" Her tone was awfully accusatory.

"...Yes?"

"I just thought you should know, I'm carrying his baby."

Was I going to faint? I was definitely going to pass out. I wanted to lash out at her, but I didn't have the strength. She slapped her money on the counter and left without her change as my eyes burned a hole into the back of her head.

Luckily there were no other customers, and I was able to make my way a few steps to the reach-in freezer. I sat on top of it with my hands on my head, trying to gain composure. My legs shook with adrenaline or anger, I'm not sure which. Was she serious? I mean, what woman in their right mind would confront another about sleeping with her boyfriend unless she was absolutely sure? I didn't know how far along she was, but I started doing the mental math. I was pretty sure no matter the date of conception, Jared and I had been seeing each other.

Another lie. Another withholding. Did he know? He had to have.

When I confronted him, I was prepared to leave him for good. He reassured me he hadn't told me because it was a lie. Her "timeline was suspect at best," he claimed. The mystery woman's name was Tori. A name I'd never heard until that day but that would haunt me for eternity. The last time he admitted to sleeping with her was two months before she claimed to have gotten pregnant.

"The bitch can't do math, plain and simple. It's not mine. Don't worry about her, baby girl. She'll have that baby, and it'll all go away."

I convinced myself that maybe he was being honest. "Girls do that sometimes," I told myself. After all, if I left him and later found Tori's baby wasn't his, I could never forgive myself.

We went on as if nothing had changed. I couldn't vent to anyone. Another embarrassment I hid deep inside. Another secret of his I was sworn to keep. They were beginning to grow teeth and eat me from the inside out.

■ ■ ■

The next week, I waited in his messy room as he showered. I looked around at the clutter, and I couldn't take it anymore. He was so gross. Picking each item of clothing off the floor, I put it in the bin. I looked at the pile of folded clothes toppling over on his chair, and as a nice gesture, I decided to put those away as well. As I opened the closet to hang a hoodie, I saw it.

A book was sitting on the top shelf. *Jared reads?* I laughed. I was curious what type of book he was into and wanted to know the title. Standing on my tiptoes, I carefully pulled it down, trying not to disturb anything else. I was shocked by what I found.

It was a program designed to help abusers who resorted to physical violence. *What?* Even worse, underneath was an activity book filled out unmistakably in his handwriting.

With my heart racing, I eagerly flipped through the pages, trying to soak up the words assaulting my eyes. I knew he'd be back any second, and there was no way he'd allow me to ever see it again. I'd always had suspicions that he was physically abusive, but he'd never hit me, so maybe he was better now? I told myself that the program must've worked.

As suspected, he walked through his door just in time to see me panicking to put it back in its secretive home.

"Just what in the hell do you think you're doing!" he belted.

"I...I...I was just putting your clothes away, and I saw this book. I was curious. I'm sorry," I stuttered.

"You should know better than to go through people's belongings. This is why I never bring you here. You just can't stop yourself from being crazy. You're not my mom. Leave my shit where it is."

His tone made me flinch like an abused pup.

"I need you to tell me why you have that book," I insisted, pretending I was stronger than I was.

"Listen, Jess, it's nothing like what you think. My ex and I were arguing in the street. A neighbor called the cops and lied to them that I was being physical with her. I wasn't, but I was forced to do this program anyway. That's all."

I knew he was lying, but I wanted badly to believe him. I wanted a better life than this. Leaving crossed my mind. But with this information, I gained a level of fear toward him that never existed before.

I tried to push all the recent hideous information to the back of my brain, but I couldn't escape it. It continued on loop all day. I was beginning to see the light in areas that before had remained dark. Things I'd labeled rough play now looked like something different; they weren't so innocent.

■ ■ ■

Midday I was lying on his bed, trying to catch a nap. He pinned me on my back, not letting me move.

"Babe, come on. I'm trying to rest," I said.

"Make me."

"Seriously, just get off," I murmured as I sleepily tried to kick him off.

"God, you're such a bitch sometimes!" he groaned as he rolled off.

I was annoyed. I shot myself into seated position. "Excuse me? Don't call me that. I didn't even do anything."

Next thing I knew, he had my arm behind my back in some hold. At first it didn't hurt. "Babe, not now. Seriously. I'm tired," I whimpered.

He pulled my elbow farther and farther up my back until my shoulder was about to pop. I was in serious pain now. I screamed, pleading with him to stop.

"Say you're sorry for talking back!" he demanded.

"I'm sorry! Please stop," I begged. He held me for a bit longer before releasing my arm. I grasped my shoulder, still crying.

"Why do you do that? I told you that you were hurting me, and you didn't stop!" I looked at him in fear.

"Oh, you know I love you! Don't be so sensitive! I was just playing."

7

Hoping things would get better proved useless. His mind games ranged from evil to sadistic; the worse they were, the more they aroused him. For example, he once tried convincing me to name three qualities I hated about him. Creating a healthy relationship certainly wasn't high on his to-do list. Why anyone would think this was an appropriate game to play when trying to build a solid foundation is beyond me. But I'll give you one guess as to who deemed it brilliant.

I quickly recognized this was a sadistic game. Clearly, he planned to use my answers against me in future arguments, or as a basis to treat me poorly in general. I wasn't going to participate in that madness. I sought to be in a place where we mended our issues, not added fuel to the already booming explosion.

"Playing this game will only divide us, babe. Please don't ask me to do this," I begged. "Let's name three things we love about each other instead!"

He ignored my pleas, looking at me like I had four heads, and instead listed my supposed bad attributes.

Everyone on this planet has parts of themselves they could work on; we are imperfect by nature. We are our own worst enemies. We focus on miniscule flaws and let those thoughts fester. But there's something entirely different about hearing a loved one describe your faults, especially when it comes with ease.

Lazy, smothering, and insecure, that's what I was to him. Unnecessarily repeating himself again and again until I began to cry. Naturally, he couldn't muster a morsel of remorse for pushing me to my breaking point. There I was, tears streaming down my face, looking at the man I loved while he hurled out each characteristic he hated about me. It was excruciating. He didn't even bother to skip a beat before blurting them out. It was as if he'd been thinking about it, day in and day out, and couldn't wait for the opportunity to tell me.

I pleaded for him to elaborate with examples of my laziness. He wouldn't. Was I smothering? I didn't think I was. He was never around for me to smother. I only asked him to do what everyone's boyfriend did without being asked. I never requested he go above and beyond, because frankly, I had shit chance of even receiving the minimum effort.

He was correct about one thing though: I was insecure. He certainly didn't help. Constantly he bombarded me with insults, called me fat and ugly, and compared me to women he found more attractive.

"Why can't you look more like that?" he'd poke. Always following with, "Relax. I'm joking!"

Despite telling me how unattractive I was, he'd occasionally throw me a compliment. I was changing into my pajamas one night when he said, "Wait."

Huh? I looked at him in confusion.

"Come here," he demanded. He ran his fingers along my naked body. "You're so sexy. I don't tell you that enough."

I was like putty in his hands when he complimented me. Why couldn't he always be like this? Compliments were few and far between, but they strung me along, hoping for more.

Sexually we were compatible. That was never our issue. But our desires and kinks couldn't have been more different. I craved a sense of intimacy, but he treated me like a stranger in bed. Like some new whore he'd picked up off the street for the night. I became no more than a vessel to throw his seed into. The longer we were together, the more my needs went unsatisfied. He never cared if I was enjoying myself, as long as he was.

He really got off on inflicting pain and being forceful. I dreaded having to give him oral, which he'd force me to perform each time before having sex. That was where he was most forceful and in control. Sometimes I felt like I wasn't even in that room with him but rather in some rape-fetish porno.

I made the mistake of telling him my nipples weren't as sensitive as other women's, and thus they didn't bring me sexual pleasure. He took it as a personal challenge or a green light to see if no pleasure meant ultimate pain. During sex he'd twist and pull my nipples without mercy until the pain became unbearable. Each time leaving my nipples so raw and bruised, I'd cry when the water brushed them in the shower. My pain was truly his pleasure.

At one point he decided choking me in bed would be our new thing. Not surprising at all, based on his porn searches, but that's a story for another time. The actual activity wasn't what bothered me; I rather enjoy a good choking when it's consensual and done correctly. What put me off was the sadistic look in his blackening eyes. It was like he'd disappear to somewhere else. Often it was violent, too forceful, and lasted far longer than I'd want. I shouldn't even describe it as choking but rather as suffocating. Sometimes he preferred to use pillows instead of his hand. A rather dangerous game, if you ask me.

I never asked for or wanted any of this. Not that he cared. During sex he'd remind me that I was his possession. I belonged to him and only him. He'd tell me I was a whore because he could "tell I was enjoying it." Maybe I wouldn't have minded this insult if I were, you know, enjoying it. I know some people crave rough sex and have no motive beyond that. But with him, I could tell it was a way to inflict pain and punish me without even raising a fist.

At nights I would lie in bed praying he wouldn't rub against me. He began to nauseate me, and I was thankful for the days he would stay at home instead of coming over. If I tried to deny him or said I was tired, he'd remind me that I was his girlfriend and that was what I signed up for.

Despite my constant pleading to use condoms, he refused. With my financial situation being what it was, I didn't have insurance or extra money

to get on birth control. He'd claim the usual delusions: too big for condoms, doesn't feel good with them, and he was fucking only me, so it was fine. With his two possible children looming over my head, I was nervous for where that left me.

To get a better grasp on the situation, I approached the subject of having children with him. He blatantly said he didn't plan to have them with me, ever. Even more worrisome, he warned he'd throw me down the stairs if I got pregnant. Not just a threat, but a promise. It left me broken. I've always been that girl who dreamed of becoming a mother; it was my one true goal in life. I couldn't imagine a lifetime without kids. As with many other moments, this should've been my time to bow out.

■ ■ ■

My feelings, he didn't care about those. He made that blatantly clear by insisting on discussing topics even after I begged not to. In particular, he was relentless in asking what my "body count" was. A dreaded conversation, as no answer is good enough. Too few is a lie, and anything more made me a whore.

Occasionally I'd mention a man's name in his presence during random conversation or when recalling a memory. He'd add it to the tally, wrongfully assuming I'd been with them. Finally, I told him eight, which was a clear lowball, and he knew it. I didn't ask his. I didn't want to know. Sadly, I suspected he'd added a few under his belt while we were together. Not that I could prove those suspicions.

He further demanded to know when, with who, and how young I'd lost my virginity. He detected a moment of hesitation in my voice, and it became his new favorite subject of torment. I refused to tell him my traumatic story, knowing he'd never let me live it down. So he used that as an opportunity to guess.

"It was a teacher. An uncle. You had a threesome. It was with a girl. You were raped!" he blurted out. He was sadistic in his inquiries and enjoyed watching me suffer. As usual, I was too unstable to leave.

■ ■ ■

One evening as I was getting ready for work, Jared randomly appeared with an old TV.

"I'm sorry to break the news, but I can't afford cable, babe. That TV isn't going to be much use here," I told him.

He laughed it off. By the time I'd finished getting ready, he'd somehow managed to rip off the neighbor's cable, without my permission, of course.

"Wait...can't I get in trouble for this? It's gotta be illegal."

"You need to chill. Someone else did it before me. All I had to do was plug it in."

"Okay, but if we get caught, I'm pretty sure I'm still the one who would get in trouble. Correct?"

Naturally, he brushed it off.

Whatever. I was used to it. "You can say as long as you want," I said as I kissed his forehead goodbye.

The hours in my shift were dragging by when suddenly I heard my phone blowing up on the counter. When I had a chance to get to it, I read, "We need to talk. I read your fucking journal you've been keeping. You're lucky I don't throw this TV through your window."

I dropped my phone in fear, thinking of the entries he'd read. Surely he hadn't opened it and stopped at one. All I did was talk shit about him in there, highlighting his every asshole move. It was my only outlet to get the darkness out of my head, now that I had zero friends. He snooped because he wanted material to taunt me with. And boy did he find it!

"I'm not coming home if you're there. With what you just read, you're in a dangerous mood, and I'm not putting my safety at risk," I responded.

Cue the bombarding of furious messages. He "couldn't believe I would say such a thing," even though he'd threatened to smash up my apartment a whole five seconds ago. I stood my ground.

"You had NO right to invade my privacy like that," I messaged, fueled by adrenaline. "If your ass is still there when I return, I'm calling the cops immediately. Don't even try to play with me, because it won't work out for you. Get out of my apartment now."

Without a doubt he was enraged by what I'd written in my journal, and I knew I couldn't trust him in this state. He'd shown me his violent temper

on many occasions. His fuse was short, his voice boomed, and he constantly told me he was going to hit me over the smallest of issues. Though his fists hadn't swung, I knew it was just a matter of time.

Thankfully he yielded to my threats, but not before making sure I remembered he had friends on the police force. *How could I ever forget?*

The following day he stopped over with some half-assed apology and promised to make it up to me by attending my family Christmas party. He knew my family was my weak spot. I'd been begging him to meet them for five months. I couldn't believe he'd finally listened. Beaming with happiness, I thanked him a thousand times for giving in.

I did feel betrayed that he'd read my journal, but I was honestly shocked at how well he seemed to be handling my darkest admissions of hatred toward him. Maybe he'd learned something from what he read. I hoped so. I was unaware he was manipulating me by using an event that was important to me to overshadow his shit behavior.

It was December 30; the Christmas party had arrived. I sat in my aunt's living room, surrounded by joyful couples and love. Sounds of children's footsteps and laughter vibrated through the home. Everyone was coupled up. Everyone but me. Jared was nowhere to be found, of course.

Despite his promise, he was still Jared. Each letdown I suffered broke me more and more. He had no intentions of coming. He didn't request off work or change his schedule for the event. His aim was to deflect my attention from his wrongdoings. I had to hand it to him, it worked.

As I sat quietly on the couch, watching the room come alive, my uncle plopped himself next to me. He nudged me with his elbow. "When are we going to finally meet your new man?"

Dad overheard the exchange and joked, "Good luck with that. I've never even met him." I looked into my lap and shrugged with embarrassment and hurt. He'd betrayed me. Again.

8

There was only one holiday tradition that my family had shared over the past few years. Growing up, we weren't the type of family to share in many traditions, so this one became important to me as soon as it started. On New Year's Eve we'd gather down the street from my family's home. My friend Anthony's parents, the ones who'd donated the furniture to me, invited us into their place year after year. Nothing big. Just people sitting around, eating food, throwing a few back while enjoying one another's company until the ball dropped. This year I planned to do the same. Since Jared hadn't asked to spend the evening with me, I asked my parents to pick me up so I could join them.

I told Jared about my plans, of course, hoping he'd attend as my date. After all, he owed me after ditching my family party the day before. Instead of blowing me off as I expected, he tore me a new one. At first, he picked on me for wanting to spend New Year's with my family. Apparently, "only children do that." But when he realized it was at Anthony's parents', it became a whole new issue altogether.

Anthony and I have been great friends since high school. We grew up a block from each other, and our parents are the closest of friends. Hell, my graduation party was at his house. After high school Anthony went off and joined the marines, and like many other of my classmates, he was deployed

overseas rather quickly. He frequently calls to catch up and check in when he can, and it always makes my day to hear from him. His friendship is essentially the only one I still hold. So naturally, I was thrilled he was home for the holidays.

But our friendship, like many of my friendships, bothered Jared. He was green with jealousy.

"I can't believe you'd even consider putting me in that situation. What are you doing this for? Are you trying to embarrass me? You and Anthony obviously have feelings for each other! You just want to parade me around in front of him to get a rise out of him. I'm not stupid."

This motherfucker couldn't be serious. I couldn't even invite him to a get-together without him assuming I had an ulterior motive.

"Seriously, Jared, that couldn't be further from the truth. Please come with me. I want you to finally meet my family, and I want to introduce you to Anthony. It would mean so much to me if you'd just come."

If he could see Anthony and me interact, I was sure, he'd understand the innocence of our friendship. But Jared wasn't interested. Instead he made me choose. And as I'd become accustomed to do, I chose him.

I texted my mom to tell her I wasn't feeling well so I wanted to stay home, then asked Jared, "Are we going to do something special? Like dinner, or at least some champagne to celebrate?"

He burst out in laughter at the suggestion. "You're with the wrong man if you think that's happening!"

Like clockwork he was snoring by ten p.m., *SpongeBob* on the television, yet again ruining the chance of another romantic evening.

As the ball dropped, a tear fell. My phone vibrated with "Happy New Year!" messages and a "Wish you guys had come! Feel better" from Anthony. I was left to cheers myself for the year of hell that was upon me.

■ ■ ■

Two months went by, and it was much of the same shit. Exhausting accusations and broken promises. A new girl started working underneath Jared at his gas station. *Sara*. She became a regular name in daily conversation and

was all he could talk about. Throughout the night his phone would ding, and he'd choose to entertain her over me. No efforts were made to hide it. He was trying to make me jealous. It was working.

I questioned him about their "friendship," which seemed too close for comfort. I wasn't allowed to have my childhood friends in my life, but he could buddy up with some stranger he'd just met? How convenient.

"She has a fiancé!" he claimed.

"*If* she is even engaged, maybe she should be spending more time entertaining her fiancé and less time entertaining my boyfriend," I responded. He reveled at the hints of jealousy I was throwing his way, but he made a point to accuse me of being insecure and jealous. No doubt about it, I was.

A few nights later, we'd just finished a delicious dinner at his parents'. As I sat in his room, which was located in the basement, Jared and Elliot were getting into it at the bottom of the stairs between their rooms. They had a relationship no different than most brothers close in age. It was up and down, and currently they were in their down phase. Who knows what had started this tiff? But I had a front row seat to their show.

Jared had Elliot in a headlock in the bedroom. As usual, I yelled for him to let Elliot go.

"Let me go, you fat fuck!" Elliot yelled.

Jared persisted.

"If you don't let me go, I'll tell Jess about the girls you bring to the hotel in exchange for cigarettes!" Elliot blurted out. Jared immediately released Elliot and chased him into his bedroom.

Through the thin old walls, I was able to hear the low whisper of threats Jared was making to Elliot. I stood up slowly and methodically, shaking my head as I gathered my belongings to leave. *I know the truth when I hear it.*

I hurried up the stairs. Jared was quickly in tow, skipping stairs as he trailed my steps. I met his mom in the foyer as I put on my winter boots. I twirled around, meeting Jared's gaze.

"Don't you *dare* follow me home, or I'll call the police. And I don't fucking care if they're your friends! You're not welcome at my home anymore! I never want to see you again! Got it?"

"What's going on?" his mother cried out.

Cocking my head to the side, I paused and responded, "Ask Jared about the girls he's been bringing to the hotel."

Into the winter chill I went. I could hear Jared's mother confronting him as I triumphantly made my way down the slippery front steps. I walked the few blocks home in the bitter cold but wasn't even phased. I was so done with his shit.

I knew more than I'd let on. Jared worked at the gas station, but I'd recently realized that he was using the business as a way to get away with illegal side hustles. I believed he'd been stealing cartons of cigarettes from his store and then selling them to friends for cheaper than they could buy them themselves. He'd no doubt pin the stolen goods on some unsuspecting newbie, who would naturally have no explanation for the product loss. Since Jared was the manager in charge of inventory and of hiring/firing people, who would suspect him of a thing?

He'd made an exchange with Elliot, who worked at a local hotel. Free cigs for a free room. Elliot wouldn't have to explain to his overprotective mom why there was a lump of money missing from his paycheck, and Jared could fuck away without being disturbed. Both parties got what they wanted out of the deal. Brilliant.

I had no doubts Elliot's accusation was true. I'd been in Jared's Jeep when he swung by Elliot's work to drop off cartons of cigarettes. I had been under the impression he'd bought them for Elliot while at work, and Elliot was just paying him back directly. But Jared didn't do nice things like that. Unless of course he was getting something in return. It was clearly something more; the equation finally added up. I didn't like the sum.

I walked up the stairs to my apartment, and before even removing my jacket, I immediately drew a bubble bath. I powered down my phone, turned on my boom box, and slipped one foot at a time into the steaming water. I didn't want to hear my phone or his shit excuses. For once I wanted to hear nothing. I sat there for hours, draining cold water and adding hot until my pruning skin begged me to stop. I made a pact with myself that

I'd be gone for good this time. I didn't need him. It wasn't like he'd been helping me emotionally, financially, or any other way for that matter.

That night was the first peaceful sleep I'd had in forever, and the only night I'd have for a while to come. The next day I awoke with vigor. I danced around my apartment, preparing for my early work shift. I pulled on my furry winter boots and clunked my way cheerfully to work, not a care in the world. The day felt different on my skin. *I'm going to be happy from now on,* I thought, *and that's all there is to it.*

As the day progressed and my shift came to a close, I grabbed a cup of hot chocolate for the frigid walk home. I still hadn't responded to Jared's mound of piling-up texts, and I didn't intend to. As I walked past the cemetery, the cup warming my frozen hands, I oddly smiled to myself. I could do this. I couldn't wait to get home and enjoy a night alone, not worrying if he'd text me back or show his face. The home that had once felt empty was now my refuge.

I unlocked my door, and as I turned to shut it behind me, I heard a strange muffled sound coming from upstairs. I slowly lifted one foot after another, climbing the stairs, bewildered. Had I left the TV on? Weird. I didn't remember watching TV this morning.

At the top of the stairs were his scuffed black work boots, right where he'd kicked them off. *Ugh, unbelievable.* Of course he'd used the key I'd previously given him to make himself at home. He clearly wasn't taking my warnings seriously.

Before entering the bedroom, I was already on a mission. "*What* do you think you're doing here?"

He stood there, looking broken, with a basket of his clothes at his feet. His bedding on top of mine.

"What is this?" I asked as I pointed my finger wildly at his belongings.

"Jess, please. Mom and I got into a fight. I don't wanna get into specifics, but I need to crash here until it smooths over. I'm sorry. I'm sure it won't be long, and then I'll be out of your hair."

"Jared, look...I can't do this with you. I want to—"

"Babe, I need you. You said you'd never leave me. How are you going to turn your back on me when I need you most? Do you want me to be homeless?"

"I said I'd stand by your side unless you cheated. I kept my word. I put up with more shit than anyone would, but you took it too far this time."

"Oh, come on! I know you don't really believe that shit. That was just stupid banter between brothers. Call him, he'll even tell you he was kidding!"

He was standing inches ahead of me. His hands reached for my hips as I attempted to take a step back, and he pulled me in. With his button nose, he nudged mine until I finally gave in and brought my eyes to his. His deep brown eyes were invasive, hypnotizing even, and they felt like home. Picking me up by my ass, he carried me to the futon and had his way with me. I didn't stop him.

I pulled on some clothes. *This doesn't change anything*, I thought. *It's only temporary. There's no way he can stand living with me. He'll be gone in no time, and this will give us both closure.*

He never left. Tensions became high the first few days, as he left his shit strewn around my otherwise spotless apartment. Dishes were littering the kitchen when I got home, after I'd spent the morning washing them all. Despite my constant nagging, every light was on when he'd leave. He never gave me a penny to put toward bills.

"I'll be out soon," he'd claim.

■ ■ ■

So much had happened since I found out about Tori's pregnancy, I'd almost forgotten about it. After our confrontation at the gas station, she'd essentially disappeared. Maybe it was embarrassment over how it all went down, but she never came around again. Jared's mom texted me to tell me he'd received a letter from family court at their house. *Ugh, great. What does she want?* Then it hit me: I didn't even know if it was from Tori or Ashley. So many children, so many baby mommas.

Turns out it was Tori, as I'd originally suspected. She was petitioning for full custody and an order of protection for both her and her child. The petition revealed Jared had been previously arrested (possibly for domestic violence, not that he'd fucking tell me), claimed he wasn't fit to be around children, and said she feared for her and her baby's safety. She mentioned in her statement that Jared had tried intimidating her into getting an abortion. *Sounds about right.*

He was furious at her accusations, but in my heart, I applauded her bravery. I didn't know a detail about their situation or about her, but he was clearly not stable enough for any of that.

How was I just realizing this? I knew nothing about him or his past. Just one topic after another that he swept under the rug. Every aspect of him was a complete and utter mystery to me.

Now that I was paying for an apartment and essentially raising a child who wouldn't contribute to the bills, my finances were stretched tight. I wasn't struggling as much as before, because my hours had returned to normal. But it wasn't much compared to the cost of feeding and housing him.

One day at work, my ex-boyfriend Chris stopped by the store to pick up some money I owed him. Since I didn't have credit yet, he had kindly allowed me to stay on his phone plan as long as I paid my monthly portion. He knew I was good for it. At this point we were amicable, and no hard feelings were had on either end.

I vented to him about my lack of money and how I was struggling to get by. He asked if Jared was doing anything to help, and naturally I rolled my eyes.

"Jess, why don't you let me see if they'll hire you at the brew pub?"

"Really?"

"Yeah. We make great money there, and there's plenty of hours available. Plus you have experience."

"That sounds perfect! Should I come fill out an application?" I asked.

"Come down tomorrow. I'll put in a good word."

I messaged Jared to see if he'd stop by the store on his way home, because I had some exciting news. He didn't respond and never showed. I was

used to it. He was asleep by the time I got home, so I didn't bother to wake him and tell him about the job.

A new opportunity was waiting, and I knew getting this job would turn everything around for me financially. The next morning, I walked the quaint road that is Market Street until I arrived at the brewing company. It was a beautiful two-story restaurant with outdoor seating on both floors. It had a rustic look to it and a huge brewing tank in the front window. The brewmaster was finishing up a batch as I arrived, and the place smelled like heaven. I paused a moment to soak it all in.

"Hey, Jess!" I heard from the bar's direction. It was Chris. I flashed a smile, eternally grateful for our continued friendship.

He handed me the application to fill out. "You pretty much already have the job; you just have to have an 'interview' with the owner," he said, with air quotes.

"Seriously?"

"Yeah, seriously!"

Apparently, Chris was assistant managing there at the time, so when he said he could get me in, he wasn't kidding. My luck was changing so quickly. I couldn't believe it.

The very next day, I sat with the owner at a small table outside his office, on the landing overlooking the stairwell, having my first professional interview. After it was finished, he said he'd be in touch. I walked home smiling ear to ear, feeling good about it. Before I arrived home, my phone was already ringing. It was the owner, phoning to tell me to come in the next day. I got the job.

"*YES!*" I screamed after hanging up the phone.

I rushed to press Jared's speed dial contact, trying to catch my breath as the phone rang.

He picked up. "What, babe?"

"You have to come home right away! I have some exciting news!"

"Ugh, okay, fine," he sighed. "I'll be over soon." He was hanging out at his parents' home—yeah, the place where he apparently still wasn't allowed to live. Liar.

Hours went by, and he finally arrived.

"You'll never guess what happened to me! I got a new job!"

"Excuse me, what?"

"Chris came in the other day to get my part of the phone bill, and he said he could get me in at the brew pub. I interviewed, and I got the job!"

I stood there smiling as we stared at each other in silence. The silence was broken with a worrisome laugh.

"You know you only got the job because you used to fuck him, right?"

"No. I interviewed with the owner. And I'm qualified."

"You're not working there."

As his fists begin to clench, I could see this conversation was going nowhere fast.

"Sorry, Jared, I don't need your permission. I'm taking the job. I need the money, and it's going to change my life for the better."

I watched as his eyebrows came together and his breathing became heavy.

"Just tell me you aren't over him. You want to get back with him, don't you?"

"You need to chill! He has babies on the way. Multiple. With his girl-friend! And besides, if I remember correctly, I left him *for* you!"

He huffed some more and left, but not before slamming the door hard enough to shake the walls. He was so dramatic. I knew he'd be back.

■ ■ ■

Despite Jared's hostile reaction, I started waitressing the next day. Soon enough I was serving tables like nobody's business. I was raking in more money than my bank account had ever seen. I knew I'd be leaving the gas station soon, because serving was far too lucrative to waste my time in that shithole.

My coworker at the gas station, Jeremy, and I made plans to celebrate after work. I was excited because it'd been an eternity since I'd actually hung out with someone besides my boyfriend. I didn't want to tell Jared about my plans because, surprise, he hated Jeremy with a passion. Secretly,

I knew he only hated him because Jeremy is black and gay. Not that Jared would admit to being homophobic or racist.

When I got home, Jared wasn't there. I figured he was off doing whatever he did and wouldn't be back for a while, so I'd just slip out. Ten minutes before I was set to leave, he arrived home.

"What, do you have a hot date or something?" he asked.

I could tell he was in a mood. "No, I'm going to go hang out with Jeremy for a bit and celebrate my new job."

"*Ha.* No, you're not. If you want to celebrate, I'll buy a bottle of wine, and you can drink it here. But you're not going anywhere near that kid. It's bad enough you work with him."

"Why can't I hang out with him?" I asked, like a scolded child.

Jared gave me a death stare before replying, "You know damn well why. I already told you no."

Told me. I hated that—as if I were a child that needed his permission to do something.

"You need to relax. Jeremy's my friend, and I'm sick of you thinking you can control every relationship in my life. You can't just make a command and expect me to listen. I haven't hung out with anyone since I met your ass! I've dropped every important person in my life, and for what? I'm going with Jeremy, and that's the end of discussion."

Just as I turned to walk away, he attacked. I was about a yard from the bedroom door when he shoved me with all his might into its frame. My left shoulder and hip slammed hard into the solid wood, sending me to the ground in pain. He stood over me, panting, with tightly balled fists.

"Don't you *ever* talk to me like that again. Do you understand?"

Overwhelmed by the stinging pain in my shoulder, I shook with fear as I held up my arms to cover my cowering head, prepared for the next impact. He stepped back, and I cautiously put them down. He faked lunged at me. Taunting me.

Still sitting in the doorway like an abused kid, I begged, "Can I at least have my phone so I can text him not to come? He'll be here any minute." Jared threw my phone at my face, but luckily, I was able to smack it down before it made contact.

I flipped it open and scrolled to Jeremy in my contacts. Briefly I paused as I debated asking him to get there ASAP. But I couldn't. I didn't want to involve him in my problem. Instead I said, "I can't make it. We'll do it another time." I knew another time would never come.

Journal entry dated February 11, 2008, 1:28 p.m.:

> *"We got into a confrontation the other day, over nothing basically. He slammed me hard into the door frame. IDK what to really do about it. I've dated an abuser before, and it always starts with a shove. If he could do that over nothing serious, who's to say he won't do something really bad in an actual argument? I stayed with him...probably against better judgment. I just don't want it to happen again...I pray it won't. I'd have to leave him for that, because no matter if I want him to be the guy I marry and have kids with, NOTHING is worth physical abuse."*

That was my last journal entry for the next ten months. He completely took away everything I loved, and I knew my thoughts weren't even safe on paper anymore.

9

There I sat on the dock, surrounded by friends, with my small feet dangling just above the water. I closed my eyes as the sun penetrated my skin. It was the perfect day. I could have more days like this if I escaped him. Really escaped him. I'd consumed too much Red Cat that day for being nineteen, but I was getting a tan, so did I really care?

It was a warm summer day; the sunbeams were reflecting perfectly on Keuka Lake. After starting at the pub, I quickly began forming friendships with the girls there. We'd been planning this girls' day for weeks, but I hadn't been certain I'd actually make it. Abusive relationships leave you canceling more plans than you attend. But nonetheless, there I was.

Being at the lake without service would bring ease to most. But I could feel the anxiety swimming in the pit of my stomach. I knew my phone was being bombarded with missed texts and unanswered calls. I knew I'd be assaulted with them the second I went into service range, and boy was I right.

It was just a day after I broke up with him—kicked him out of my apartment, took his key, the whole shebang. I couldn't pinpoint one exact reason why I'd left, just the entire herd of white elephants in the room. He was manipulative, controlling, and violent...but little did I know, I hadn't seen the tip of the iceberg yet.

The sun went down for the night, and our sunburnt bodies began to chill. My girlfriend Jackie asked if I was ready to go home, so home we went. Thankfully I didn't have a car, because I was drunk drunk. As we wound down West Lake Road, my phone began to ding. The front screen of my maroon flip phone confirmed my fears. With sweaty palms I nervously flicked it open, preparing for the worst. Forty-seven text messages, twenty missed calls, and four voice mails. Typical.

I wanted to throw my phone out the window. Or myself out of the car, to be honest. I began with the texts, and what I read was no surprise to me. He knew I was going to the lake. He knew I was having a *girls'* day.

The first messages were sweet, like any manipulator's are: "Babe, please let me come home. I'm sorry." "Please answer me." "I promise I'll be the man you need me to be." Twenty minutes later the messages became more disturbing: "You're a drunk slut." "I know you're fucking someone, that's what whores like you do." "You think you're so sneaky, but I know what you're doing. You just wait."

The ominous threats shook me to my core. I knew with him a threat was more of a foreshadowing. He'd lost control, and he was spiraling. I'd dealt with this before. I'd be okay. I thought.

The first voice mail was sweet, wishing me a good day, saying he was sorry and he missed "us." Blah, blah, fucking blah. The following ones got louder, darker, scarier. I could hear the desperation in his voice, the anger rising from below. He tried to conceal that he was a ticking time bomb, but then like clockwork…he detonated. I couldn't finish these voice mails. It was too much for my sober self, much less my drunk self.

As any drunk girl does, I cried to my friend. Jackie told me for the thousandth time that I had to leave. Not just "go on a break," but really get away this time. I knew she was right. A life with him would lead to an early death.

She didn't want to drop me off at home; she wanted me to stay with her. Miss Independent that I was, I declined. I was fine, I insisted. Over and over Jackie asked if he'd be waiting for me. I said no, which I knew was a blatant lie.

I made her drop me off down the street and around the corner. She was hesitant, because she wanted to make sure I got inside okay. I didn't think it was a good idea. I knew Jared was watching and waiting. An idling car would just bring attention that I'd arrived. If I crept through the dark streets, I might be able to get inside unnoticed.

I snuck between some parked cars on the opposite side of the road. Squinting with drunk eyes, I searched for his parked SUV. I didn't see his car...which didn't mean much. Walking close to the vehicles, with my head on a swivel, I attempted to shrink myself. When I was certain I wasn't being watched, I darted across the street, up to my apartment, and unlocked my door. Every atom inside me was roaring like drops of water in a boiling pot.

I stood inside my door, silent, holding my breath. I could hear my heart pounding.

This isn't normal.

I thought I should keep it dark in case he was watching the apartment. Using the dim light from my phone screen, I stumbled up the stairs. The apartment was dark, but it felt...different. Anger that explosive, you can feel in the air.

At first, I didn't see him. I didn't expect him to be *inside*. After all, I had his key. In my small studio apartment, I had a floral love seat at the top of the stairs. Like the psycho mastermind he was, he'd situated himself on the far side of it, so I couldn't see him as I climbed the stairs. I propped my wobbly self against the wall and set down my purse to remove my shoes. Just then, I heard the smallest movement within my otherwise silent apartment.

I froze for a moment too long.

I lunged for the stairs, not caring if I fell down them. I needed to get out, and get out now.

"Bitch, you're not going anywhere!" he hissed through gritted teeth.

I could see the streetlight through the front door, and it seemed miles away. Just as my foot hit the first step to freedom, his clenched fist tangled in my hair. He flung me back with all his might, tossing me across the room onto the love seat. My phone was no longer in my hand,

and I could hear it land at the bottom of the stairs. He was standing between me and freedom.

I screamed, *"Help!"* with every fiber of my being. Help didn't arrive.

My neighbors often heard me screaming and him destroying my things, so it was just another night for them.

Hearing me scream triggered the monster inside of him. I was scared, and that was how he liked me best. He lunged at me, and in the pitch dark, I attempted to kick him away. He was bigger, heavier. But I was faster, and scrappy. I kicked him in the ribs hard enough to get off the love seat and run across the living room, which was also the kitchen, to the bathroom. I didn't make it.

Face first I hit the small patch of linoleum in the kitchen. In seconds his forceful hands grasped my ankles and aggressively pulled me across the floor. I tried to grasp any surface I could find, but it was pointless.

I successfully flipped myself onto my back, and the dragging stopped. In that moment we were still. We made eye contact for the first time, as he still held my ankles tightly in his hands. His brown eyes were black as the devil's. A shiver chilled me to my bones. Any remnant of the man I loved was gone, and I knew this nightmare was just beginning.

I used the opportunity to attempt to kick my legs loose, screaming, "Let me go!" I got one leg loose, flipped over, and dug my fingers into the floor, desperately trying to crawl away.

Next thing I knew, he was sitting on my back.

"You think you're so fucking smart," he snarled. "You're stupid, you know that? No one's coming to save you. No one cares about you; you're a fucking drunk."

I screamed for him to get off as he slammed my face into the carpet, demanding my silence.

"You wanna scream? I haven't given you anything to scream about. Yet."

Again he intertwined his fingers in my hair. With all his might, he aggressively rubbed the left side of my face back and forth on the low, rough carpet. I could feel the rug burn forming. I felt like I was on fire. I lay there absolutely still, not struggling. Like a rag doll in his hands.

He asked me if I liked it, and then he did it again, twice as long this time. I wanted to scream. I wanted to cry. But I wouldn't give him the satisfaction. I knew he was getting off on this. On my pain.

He sat on my back for another minute. I could feel his heavy, overweight body struggling to catch his breath. The air that escaped him settled with a hot burn on my bare neck. He was tired.

I didn't move. I didn't speak. I felt his weight slowly peel off my back. As I gently rose to my feet, I prayed it was over.

He sat on the floor, head in his hands. Like *he* was the victim. He reminded me of a scolded child.

"Why do you make me do this to you?" he asked, muffled by his hands.

"I'm going to the bathroom, and I want you gone by the time I'm out. Do you understand?" I sternly ordered.

"Yes," he whispered.

I went to the bathroom, locked the door, and sat against it forever. I listened as his heavy body made its way down the creaky stairs, the door finally shutting behind him. I gasped for air, breathing for the first time in what felt like hours, and I began to cry hysterically.

I don't know how much time went by, but eventually I was able to bring myself to my feet, and I stood in front of the mirror. My nose was starting to swell from hitting the floor, and my left cheekbone was rubbed almost raw. My tears literal salt in my wounds. My nail beds bleeding as I wrapped my hands around the counter's edge. I stared at my reflection. *How did I allow myself to get here? Again?*

I sat on the toilet to pee, with my torn face in my hands, sobbing. Over my tears I heard a recognizable noise. Slowly bringing my head up, it hit me. He was still out there.

I reached for the toilet paper and froze with confusion as I heard the empty wine bottles I stored on top of my fridge clink against each other. Why was he in the fridge?

In a matter of seconds, he burst through the locked door. Standing in the doorway, he had a magnum of Red Cat in one hand and the other clenched around my phone. There was a storm brewing in his eyes, and I knew danger was ahead.

His lips barely parted as he slowly and angrily asked, "You told your friends we were over? We are *not* over! We'll never be over."

I'd had enough of his shit. Pulling up my pants, I told him to get the fuck out of my house. My phone bounced off the wall next to me as he simultaneously pushed me back onto the toilet.

"Oh nooooo. You want to drink? You want to have fun without *me*? You're going to drink this whole thing."

I attempted to push him away. "You're crazy!" I screamed.

He bounced the right side of my head off the wall and forced my mouth open. With my head wedged against the bathroom wall, he began to drown me in the wine. I tried to spit it out but was beginning to choke. He didn't care. He screamed for me to swallow it. He didn't stop until each drop was gone. A mixture of wine and tears soaked me to my core.

"What? I thought you liked being wasted," he muttered as he walked away triumphantly.

How could he claim he loved me when he treated me like this? Again, and again. How was this love? I wouldn't treat me worst enemy this way.

I picked my phone up, and the indestructible thing still worked.

I wasn't scared anymore. I was irate. With all self-control gone, I sprang after him, pushing him from behind toward the stairs.

"*Leave!*" I screamed. "I'll call the cops."

"You think they'll care about you, you little slut?"

He refused to go, so I threateningly opened my flip phone and began dialing. Nine. One. Then bam, I was body-slammed to the floor. Again separated from my phone. My ears were assaulted with a familiar noise, immobilizing me in an instant. His hunting knife had been flung open. A sound that will haunt me until the day I die.

He'd asked for the knife for a Valentine's Day gift. Why did he need it? He didn't hunt, but I still bought it. Beth hated that I'd given it to him, which should've been my first clue. I now realized my mistake. It was a giant red flag waving in front of me, waiting for me to take notice.

The knife wasn't meant for an animal at all. The knife was meant for me.

I felt the cold metal push against my throat.

I wasn't scared. I hoped he took my life; I didn't want to live like that anymore. Then maybe everyone would see him for the monster he really was.

In a flash of stupidity or bravery—that's still up for debate—I pulled my head off the ground, pressing my neck hard against the blade, taunting him. "*Do it.*"

Something wasn't right. As hard as I was pressing, I should have been bleeding. The knife should have been cutting right through me. I could feel the cold metal against my skin, but...it...it wasn't sharp.

This fucker. This coward. He didn't even have the serrated blade against my neck!

As soon as the realization hit, I began laughing like a lunatic. Any fear I had quickly dissipated.

I looked him dead in the eyes. "I always knew you were a little bitch. You can't even try to kill me right. Coward."

I didn't care what I said, and I surely didn't care what he did next. Turns out after you're threatened with having your throat slit, one of two things happens: you become a victim, or you lose all fear. Fight or flight is a son of a bitch; adrenaline was always my favorite sidekick.

He got off me, tossing the knife aside onto the love seat, and said, "Jess, I'm sorry! I would never hurt you!"

"Well, that's fucking rich, isn't it?" I mocked.

I tried to stand, but the wine was catching up to me. Wobbly like a newborn fawn, down I fell. The already dim apartment faded to black, as did my memory. What happened next was a mystery only he'd know.

*Bzzzz, bzzzz...*I opened my swollen eyes and turned off my alarm. Staring at the ceiling in confusion, I tried to piece together the night, but most of it was a blur. Next to me he lay sleeping silently. Anger welled up inside me, mixing with other emotions. Crawling from bed, trying not to wake the beast, every fiber of my being ached. And I knew it wasn't just from the alcohol, which was clearly still intoxicating me.

I quietly opened my bedroom door. Evidence from the previous night littered the room before me. His knife lay on the love seat, and the empty bottle of wine on the linoleum where it'd fallen. Flashes of memories

started to come back, and I immediately began panicking. I picked up the knife and hid it in the cushions, where it remained for years until Dad accidentally found it.

I put my hands on my head, feeling my entire scalp recoil in pain. Shit. I knew I needed to make a plan to get him or me out of the house. He knew my schedule, so he'd remember it was my day off.

I'd lie. I'd say when I was at the lake, I had agreed to pick up one of the girls' day shifts at the pub. I was always picking up extra shifts, so that would do. Nothing too elaborate or suspicious.

I went into the bathroom, shutting the now-broken door behind me. *Great, another thing I'll be paying for.* I shook my head at the Red Cat stain on the floor as I slowly undressed to face the woman in the mirror. She looked rough, but she felt worse. A shell of my former self stared back at me.

Pulling back the half-torn-down shower curtain (no clue how that happened), I reached for the knobs to warm up the shower. Immediately I began to sober up and sob silently. Shakily I put one foot, then the other inside the shower. I gently massaged my bruised scalp with shampoo as the water washed away my tears.

As I pulled back the curtain, I pulled myself together. *I won't let him see me weak like this. I'm not weak, and I'm going to take back my life. Even if it fucking kills me.*

Just then, I could hear the bedroom door open, and I held my breath, preparing for his entrance. I wondered what he was feeling, seeing the scene before him. I could feel his presence standing just on the other side of the door.

"You may as well come in. Not like I can lock it now anyway," I snarled. Now that I was not intoxicated, I was going to play the strong-woman card the best I could. The door creaked open, and he stood there, staring at his feet, pretending to be defeated.

"Can I help you? I'm busy."

"I'm s...sorry," he stuttered.

"Oh, sorry? Exactly what are you sorry for? I want you to *tell me* word for word what you're *pretending* to apologize for, because I'm not buying

your 'I'm sorry' bullshit anymore." He wouldn't even look up. "You know what, forget it. I don't want an apology from you. You're a coward. I want you to leave."

He stood in the doorway and slowly looked up.

"I said leave."

"Where are you going?" he asked accusingly.

"Not that it's any of your damn business, but I picked up a shift from one of the girls last night. Now if you don't mind, I need you to leave me the hell alone so I can attempt to cover up this mess you made!" I yelled as I pointed to my face.

"Jess, I really am—"

"*Get the fuck out!*" I interrupted, eyes bulging. I wasn't asking anymore. This time he retreated and left the apartment without struggle.

With the miracle of makeup, I made myself halfway presentable. If anyone asked, I'd tell them I drunkenly fell down my stairs. Some of them would accept the lie, and others would know it was him. I put on my uniform, knowing he'd be somewhere watching me as I walked to work. I needed to make it believable. I didn't think he'd be ballsy enough to come after me again if people were expecting me to be somewhere. I was right.

When I showed at work, my manager took one look at me and asked, "What the hell happened to you?"

"I fell down my stairs," I claimed as I stared off blankly at the wall behind him.

He looked at me suspiciously and questioned, "You know you don't work today, right?"

"Shit, really? Oh. Well, I'm going to hang out here a bit before walking home. It's hot out there."

"No problem," he said as he polished a pint glass, watching me suspiciously.

I took a seat in one of the creaky wooden booths. Staring at my phone, I tried to decide my next move. Then it hit me. How did he even get in? I already took his key. Oh. Of course. An abuser always thinks ahead to make a spare. You know, for the rare case you dare leave them. *Great.*

I called my dad, and without explaining much, I said I needed help changing my locks. I told him Jared and I had broken up and that I just wanted to feel safe in my home. He agreed to come up that afternoon and help me with whatever I needed.

Later that day, my dad took me to the hardware store. On the short ride, he didn't ask any questions; he wasn't one to pry. The metallic smell of the store filled my nose as we walked around. Being in his company and not admitting what I'd just experienced was painful. I wanted so badly for my dad to just save me, to tell me everything was going to be okay. But I couldn't tell him.

I'll never tell him, I thought. But like many others, he knew. Makeup or not, it was written all over my face.

While we were there, I felt my phone buzz in my pocket. My heart began to race, and I was hesitant to look at the screen.

It was him.

"I just wanted to message you and let you know I've decided to give you your space until you're ready."

The nerve of him, acting like it was up to him whether or not I got space! *You've* decided? Oh, thank God he'd given me permission. And until I was ready? What did that even mean? Until I was ready to get my heart and face broken again? *Well, I've decided that you're dead to me. You don't get a response. Go choke.*

■ ■ ■

I'd became accustomed to the darkness. Many nights I sat alone in the blackness of my apartment, listening music on low. Haunted. I'd hear the distinct sound of his engine as his shitty Jeep rolled down my street, slowing in front of my apartment. Undoubtedly, he was spying to see if I had a visitor occupying the space that was once his. That first night, I didn't stay alone. Nor did I many nights thereafter.

One late night at work, Jackie and I drank a beer as we did our end-of-night checkout. I expressed how annoyed I was with myself that I still was longing to hear from Jared.

"Look, in order to get over someone, you have to get under someone else. Trust me," Jackie encouraged.

That seemed like ridiculous advice. But if I wanted to get over Jared, I needed to be willing to give anything a try. What did I have to lose?

As cliché as it was, the sexy busser from work, Peter, had been catching my eye. We had one of those server/bus boy flirtationships. Everyone who has ever worked in a restaurant knows exactly what I'm talking about.

Could I do this? I know, Jared had had a "work girlfriend" this whole time. Probably ten, if I was being honest. This would just be returning the favor. If he could have fun, why couldn't I? Not that I was with Jared, or owed him shit.

When I began working at the pub, Peter and I immediately hit it off. We both worked ourselves to the bone there, and I spent more time around him than I did Jared. Our relationship was full of banter and fun, but it had never crossed the line. Or at least, not yet.

Peter seemingly fulfilled any need I had before I even expressed it to him. I'd text him, and he'd immediately respond. Any subject I spoke to him about, he had an intelligent response. The attention I wanted, he returned tenfold. It only encouraged me further.

I chose not to tell Peter the details of that fateful night with Jared. Hell, even without the details, Peter wanted to kill him; he had a zero-tolerance policy for men mistreating women. But I sent Peter a message: "If I'm being honest, I'm scared to stay alone. I keep thinking he's going to show."

"I'll come be your bodyguard," he offered.

The message drew a smile across my face. "Yes, please!" How could I refuse that offer? Despite Peter being several years younger than Jared, I knew if need be, Peter could take him with ease. He was in peak shape, and Jared was on a race to cardiac arrest.

Peter came around that night, and many nights thereafter. We'd sit around watching TV, smoking pot, and laughing at each other. He was the exact distraction I needed.

We crossed the threshold into friends with benefits, and I was enjoying all his attention and fun we were having. Despite my enjoyment,

though, I couldn't commit to him. He wanted me to be his girlfriend, but how could I? I was still tethered to Jared in some invisible way. Selfishly, I kept it going with Peter, because it was nice to feel wanted. To feel safe.

But that feeling of safety didn't last long. In the following weeks, I began finding little notes from Jared stashed around the apartment, igniting fear each time.

"You don't need makeup. I love your 3AM beauty," read the one in my makeup drawer.

A week later, while looking through my closet for a clean work shirt, I found another that read, "I want a future with you, babies and jet skis."

I was petrified of drowning; what the hell did I want a jet ski for? Probably just another toy to torture me with. *Fuck his imaginary future.*

I sat on my bedroom floor. When had he left these? Did he do it that first day before I changed the locks, and I was just now finding them? Oh my God...what if he had been breaking in? How many more notes were hidden around? *I'm going to text him and rip him apart! No. No, he wants a reaction. I can't give him the satisfaction.*

I pulled on my pink brew pub T-shirt and began walking there. I was riddled with a paranoia I couldn't shake. Where was he? Was that his car parked ahead? I changed my route to avoid the main road. If he was stalking me, I wasn't going to make it easy on him. I was managing to avoid him physically, but I hated that he was haunting me mentally. He'd taken up rent in my head, refusing to be evicted.

I waited for his next strike, each day fear building. The anticipation drove me insane. Weeks later, in the deep of night, my phone buzzed. It was him.

"You up?"

10

Midnight: *Fuck you!* Ugh, the audacity he had to text me! No. I wasn't texting him back. Or ever talking to him again. He was dead, dead to me.

Three o'clock: I stared at the ceiling, still awake. *It would be nice to have someone to cuddle right now...No, Jess! Snuggle your damn pillow. It's not happening; you know his ass doesn't snuggle anyway. Stop kidding yourself. You should've had Peter over if you wanted to cuddle.*

Five o'clock: Flipping sides with a heavy sigh, clearly still awake. I absentmindedly sniffed his pillow, pulling it close. *Maybe I should just text him back.* I'd just ask what he wanted, then end the conversation. Maybe he was actually going to apologize. He owed me that much. Obviously if I messaged him, I'd be mean. I'd never be nice to him again.

Eight o'clock: "Sorry, I was asleep," I nervously typed out, erasing, typing and erasing, and typing again before pressing send. Why was I apologizing to him? Especially for sleeping—not that I even had. Stupid. I was so fucking stupid.

You know when you make a bad decision? A really bad, life-altering decision, and you immediately want to take it back, but you can't? That's how I felt after pressing send. But when he responded, instead of righting my wrong, I made the next very bad decision, and then another. Until

they piled on top of each other, and suddenly I was getting ready for him to come pick me up.

Yeah, it happened that fast.

Basically, it'd taken the words "I miss you" for my brain to catapult out of my body. All the self-care I'd done, all the work I did on myself for weeks, was ruined in a matter of minutes.

At first, I played it cool. I told him I planned to do laundry. But he played it cooler and said he wanted to give me a ride to the laundromat as a "kind gesture." He knew I didn't have money lying around for a taxi, and I'd otherwise be carrying my laundry to the other side of town. He was manipulating me, using my weakness for his benefit. And I was falling for it.

I paced back and forth in my room. I wished I had a friend here to talk me out of the horrible decision I was making. *Okay, pros and cons, what are they?* Obviously, I needed to see him to get closure. If I saw him one last time, I'd know I made the right decision. Ugh. Plus, he did owe me a fuck ton of an apology. Those were the pros. Seems like I forgot to highlight the cons.

"Okay, but only because I need to do laundry. This is on a friends basis only!" I replied. Shit. I shouldn't have used the word friends. I didn't want him in my life, and that gave him the wrong impression.

Jared agreed, and a few minutes later, I heard him pull up out front. A swarm of bees were buzzing angrily in my stomach. I was so nervous, I considered vomiting. Throwing up would've been a better life choice than I was about to make.

Carrying my basket of laundry through the living room, I was paralyzed with a flashback of the assault that occurred there. Red flag. I continued, descending the flight of stairs ahead. Each step calculated, shaking like a leaf. After closing the front door, I wiggled the handle a few times to ensure I locked it. Nonsensical considering I was about to go on a joy ride with the real threat.

Slowly I turned my sight to his Jeep, which was idling by the sidewalk. There he was. He looked at me as if I was a stranger, and I had that "I've met you before" feeling.

By the passenger's side he stood, door open wide. Grinning from ear to ear. Jared didn't open doors, but of course I didn't consider that in the moment. My brain had left my body. Common sense wasn't guiding me anymore.

On the floor in front of my seat was a big bag of Wendy's; a large chocolate Frosty sat in the cup holder. *He remembered.* He'd bought all my favorite foods from Wendy's. I'd ordered in front of him a million times. But I swear every time we'd pull up, he'd pretend he didn't remember.

Jared never remembered my preferences or what I enjoyed. Or that's how he played it off. Why was he putting in the effort now when he never did before? To most people the gesture would have seemed trivial, but it was so unlike him that I mistook it as changed behavior. The thought fucked with my head.

He instructed me to get in while he put my laundry basket in the back. This experience felt familiar and unfamiliar all wrapped into one.

Surrounded by the buzzing sound of the old machines, we sat in the laundromat for hours. We were the only ones there, but for an unknown reason, I felt safe. As I dipped my fries into my melting Frosty, we talked about anything and everything. He was kind and didn't ask me any of the pressing questions that I assumed he would. He never asked me if I was seeing someone, if I'd hooked up with anyone, or if I'd told a soul what he'd done…none of it. Instead we joked, we laughed, and we flirted as if our dark past didn't exist.

We were like strangers on our first date, and I could feel myself falling down the rabbit hole again. We sat intimately close but still not touching. The desire to reach out was overwhelming. In a brief moment, he casually attempted physical contact by brushing his knee against mine. Likely trying to gauge my reaction. I could tell right then it was all over for me. I knew if he wanted me back, he could have me. All of me.

At the snap of his fingers, I forgot why I'd let him go in the first place. Okay, so maybe I didn't forget. I'd never forget. But I again chose to make excuses for him and overlook it all.

I knew he was violent with me, but only because I'd left him and cut him out. Anyone would be angry in that position. I'd caused him

so much pain because I didn't stop to consider his feelings. I could've respected his wishes that day and not pushed him by being gone so long. Because of my poor choices, I'd caused him unnecessary worry. I knew he hated when I drank outside of his presence. If I had stayed sober, this all could've been prevented.

I made all these excuses for him and more.

We had a long talk that night about our desired futures. I was clear that my future vision included him, but I required more of a commitment from him if I was going to move ahead.

"Jared, I want to get engaged. I'm not just going to play house with you forever. And when my lease is up, I want to move in together, in a different apartment that doesn't have all these bad memories. I want it to be *our* home. But I need your help financially. I can't keep supporting us on my own, and you shouldn't expect me to. You need to pull your weight."

He agreed to my terms without hesitation.

"One last thing. Kids aren't a negotiation for me. I don't want them immediately, but down the road, it's a certain for me. Being a mother has always been my number one goal in life. If you feel you can't provide me with that, that's fine, but I need you to let me know now."

Jared wrapped his arms around me and kissed me on my forehead. "Babe, I will give you all that and more. I realized when you were gone that you're everything I needed in life. I'm ready to be serious this time."

I allowed him to move back in that night.

I knew I needed to break the news to Peter, and I was dreading it. I wasn't ready to tell anyone I'd taken Jared back. Maybe I could avoid the discussion and just phase him out. But I soon realized how connected we'd become. If I wasn't at work, we were texting. So I became short and cold in our conversations. I lived in fear each time my phone buzzed, worried it would be Peter and Jared would see it. After each shift, Peter asked to hang out, but I always had an excuse. I realized I had to cut the cord.

I knew it would break him. Boyfriend or not, he'd become attached. I asked him if we could talk, and he instantly knew whatever we once had was coming to an end.

"You're going back to that fat ass, aren't you? How could you choose him over us? We were good together. I would never treat you like he did. Please, Jess. Don't do this."

I lied, because I was ashamed. Deep down I knew Peter was right. I was making a horrible mistake. A mistake that would haunt me for life. After that Peter became cold toward me, rightfully so. One of the many victims I left behind on my path of self-destruction.

■ ■ ■

For a while, I didn't tell a soul I was seeing Jared again. I was embarrassed, because it was a stupid choice. I forbade him to bring me to work or pick me up. I avoided mentioning him during conversations. Still, my friends and coworkers caught on. The worst part was they weren't surprised. They never thought I had the strength to actually leave. They were right.

For a week Jared was on his best behavior, always coming home and communicating appropriately. Then just like that, it was back to life as usual. It was a predictable cycle, yet I was blind to it. He'd fuck up, draw me back in with sweet gestures and supposedly changed behavior, and then go back to screwing off until it all came to a head, and he fucked up again. Rinse and repeat.

I was beginning to regret taking him back. But after what happened when I left last time, I was terrified of the prospect of leaving again.

I harassed him about all the promises he made when I agreed to take him back, and I pointed out how he wasn't making good on them. I didn't think I'd ever get a ring out of him.

He wasn't around much anymore. He'd recently begun volunteer fire-fighting again for a local department. He would've loved to get into the city's paid fire department, but he knew with his prior domestic history, they'd never allow him. The volunteer departments, however, were laxer. They didn't have a giant pool of volunteers, so who were they to turn someone away?

It was a Tuesday, and just like every Tuesday, he had a training at the firehouse. He ordered me to wait for him to get home from training to

eat. Yes, ordered. Hours and hours went by, and I was starving. In both frustration and hangriness, I sent him several messages asking what time I could expect him. This training was taking significantly longer than usual. No response. I'd finally had enough of my stomach eating itself, so I made Easy Mac for dinner.

About an hour later, I got a text from him: "I'll be by in a second. Be ready, we are going to Wendy's."

"Stop on your way home. I've already eaten."

"I told you not to eat. Be ready, I'm almost home. You're coming."

"No. It's out of your way to come get me. Just go to Wendy's."

My phone began to ring, which I had seen coming. He was insistent that I go with him, getting angrier as the seconds passed. My insides were boiling. Everything was always on his schedule, and when he said jump, he expected me to jump.

I pulled on my shoes, intentionally leaving my purse behind. I wasn't stupid; he would make me pay if I brought it.

It wasn't supposed to be like this again.

As the Jeep pulled up, I exited the apartment. I started to dish out the attitude the second I got in the car, but he didn't give it back. *Strange.* He pulled into Wendy's drive-through to order. I stuck to my statement, insisting I didn't want anything. I kind of did, but a girl has to stick to her guns.

On our way back into town, Jared was speeding, which wasn't exactly out of the ordinary. Suddenly I saw flashing red and blue coming from the rear-view mirror as the police pulled out from their hiding spot on the side of the road. *Shit. Shit. Shit.*

"Wow, really, Jared?" I said, my eyes bulging from their sockets. He shot me a look and shrugged as he pulled into the large empty parking lot to the right. The police pulled up behind our car, lights still flashing.

A younger officer got out of the patrol car and approached the driver's side. He did the usual "do you know why I pulled you over" bit, and Jared admitted to speeding. He handed over his license and registration, and the officer went back to the patrol car to run his info. When he returned to the driver's side window, he asked Jared to exit the vehicle.

Great. I started eating his fries. *Knowing Jared, he probably has an outstanding warrant I don't know about. He's so annoying.*

Jared was taken to the rear of the vehicle, just out of my line of sight. The officer then walked around to my window, gently knocking. As I rolled it down, he asked for my ID. I admitted that I'd left the house in a hurry and didn't bring my purse. He looked at me with suspicion, so I said, "We live up the street. We were only taking a quick trip to Wendy's. I didn't think I'd need it."

The officer asked me several identifying questions, such as my date of birth. Just as I assumed his questioning was wrapping up, he asked, "Will you please step out of the car, miss?" Certainly this was a demand, not a request. *What the fuck.* I was going to kill Jared when we got home. I'd only ever been in one car that had been pulled over, and I wasn't asked to exit. Now I was shaking like a leaf.

I clumsily unbuckled my seat belt, did as the officer demanded, and exited the car. He sternly instructed me to go around to the rear, and I carefully did as I was told. When I got there, Jared was on one knee.

I stopped in my tracks.

At first, I didn't even notice the ring in his hand. *What are you doing?* I wanted to shout. *You're about to be shot for disobeying the officer's orders!*

It wasn't until I listened to what he was actually saying that I realized he was proposing to me. I was in absolute disbelief. *Seriously, there couldn't be a worse time than this, Jared.*

The officer asked, "Well, are you going to answer him?" I looked at him in bewilderment, and that's when I noticed the other officer standing near the patrol car. He was the Collins's family friend. That's when it hit me. This was planned, all for show. Of course it was.

I wanted to say no. But I couldn't embarrass him in front of these officers. He'd kill me for that.

I said yes, but not before giving Jared a good smack on the arm. What was I supposed to do?

He thanked the officers for helping him pull off the engagement, as did I. And even though I'm sure it's against protocol, they gave us the dashcam recording, an everlasting memory.

On the short drive home, I got to thinking. I'd always dreamed of that moment—who it'd be with, where, and how I'd feel. I felt nothing. This moment just felt, I don't know, incomplete. *Shouldn't I be feeling an explosion of emotions?* None of my friends were engaged. I had no one to compare feelings with.

When we got back home, I crawled into bed to watch a movie, not even changing into PJs. The questions began.

"So. Don't you want to call anyone to tell them the *happy news?*"

"Oh, it's late. I'll call some people tomorrow," I replied.

Jared looked at me with suspicion, picked up my phone, found Sam's number, and called. He threw me the phone. We spoke briefly before he made me call Aleisha to tell her. Their reactions were as expected: confused but polite. I got it. I was confused too.

This was what I'd asked for. I'd practically begged for it. I couldn't leave him now. What kind of woman left after making ultimatums and getting what she wanted? I couldn't be that girl. So I went on as if everything was okay. It was very much not okay.

■ ■ ■

The clock was ticking on my next ultimatum: a new apartment. At least I could get excited about this one. Our current place held too many traumatic memories, and I needed a fresh slate to start with if we were really going to do this. I couldn't even walk through my living room without shuddering. PTSD was a son of a bitch.

Now that we were combining finances and I had a higher-paying job, I was happy to see what type of apartment we could afford. I began to daydream about all the nice decor I could furnish it with, and I cracked a smile. Maybe life was about to turn around.

I wanted to stay on the hill, the part of town where my current apartment was located. It was the perfect area for me since I still didn't drive. I was used to the neighborhood, and it was a short walk to work, his parents', as well as anywhere else I'd want to go.

Jared, however, disagreed. He insisted he needed to be closer to the fire department so he could be one of the first ones there when they got paged out. Sometimes too many others got there first, and there wasn't room for him on the fire truck. He could still go to the scene, but apparently, not arriving via fire truck made him feel some type of way.

I was angry because he wouldn't compromise at all. When I admitted I didn't feel safe walking through the shady neighborhoods in the dark, he told me he didn't care. He refused to even look at apartments on the hill. What had happened to the man that cared about my safety?

I didn't have long before my lease was up, and he was being difficult. I knew I wouldn't get my way, so I agreed to look at two-bedroom apartment on the north side of Corning. It was in our price range, and spacious. I was happy heat was included so I could finally be warm.

We viewed the apartment and prepared to sign the lease as the landlord drew up the papers. Jared pulled me aside and insisted that we should only put my information on the lease, since they were doing a background check and credit check.

I don't even want to know. He was hiding something.

I should've dug deeper. If we were going to get married, his financial burdens were about to be mine. I had no idea what darkness was in that closet.

The landlord handed over the set of keys. Yes, our first official apartment together!

We didn't have much, but we had each other. With minimal belongings, moving was cake. I had saved up a little extra money, so I treated myself to a new platform bed and memory foam mattress. The best life choice I'd made in a long time. We put his tiny old bed in the second bedroom, along with some other odds and ends. Even though the apartment wasn't in an ideal location, I was determined to make the most of it.

After moving in, I sat on the love seat and placed a call to my momma to catch up. During our conversation, she said one of the strays who hung around her house had recently given birth to a litter of kittens. In my last apartment I was forbidden to have animals, but my new lease didn't say I couldn't.

When Jared got home that night, I mentioned the idea to him.

"Under no circumstances are you getting an animal. Especially a fucking cat. We are a dog family if anything. Our first pet will be a golden."

Fuck him.

The next day while he was working, I had my mom drop off a kitten. It was the runt of the litter, and as runts usually do, it had a spunk about it. Its coat was short and the perfect mix of gray and white. As I watched it dart around my apartment, climbing everything, looking for new hiding spots, my heart slowly warmed. I felt a happiness that I forgot existed.

When Jared came home from work, I'd half expected him to kill me. But he didn't. He slowly walked to the middle of the living room floor where the kitten was lounging on its back. He picked it up off the floor, bringing it face to face.

"We are going to name you Liberty," he stated.

"Absolutely not! We aren't naming my cat after your favorite emergency light bar. That's just stupid!" I yelled. Who wants to name their kitten after a stupid flashing light.

Initially I thought the kitten was female, so I agreed to compromise on the name Libby. Turned out Libby was a boy, but I didn't care. I had my kitten.

■ ■ ■

Things were good when we moved to the new place. I get nervous when things start to feel too good. I'm always waiting for that other shoe to drop. And it did. That morning as I was making breakfast, I heard the door shut. That was strange. Wasn't Jared at work?

"Babe?" I yelled from the kitchen, stopping what I was doing.

"Yeah, it's me. Come out here, please, we need to talk."

Oh God.

He sat on the love seat and gestured for me to do the same. I sat down beside him and began picking at my nailbeds. "Babe, just tell me what's going on."

Looking at the floor, Jared took a deep breath and said, "I was let go today. I've been changing my time card on the computer for a while now, and someone caught on."

"How much time are we talking, Jared?"

"Well, you know me, I always came in when I felt like it and took long lunches. So I wasn't really collecting extra hours…I was just saying I was there the hours I should've worked but didn't."

"Jared, that's a lot of money! Are they pressing charges?"

Jared admitted they wouldn't press charges if he agreed to repay a huge sum. In reality the sum was much smaller than what he'd actually ripped them off for over the years.

"I'm sorry…I can't help with rent," he said. "I need to pay them back."

I got up and paced the room. I wasn't even mad that I had to pay the entire rent. I could afford it. But I was furious that he continuously made bad judgment calls like this. He was so impulsive and didn't care who was hurt in the crossfire.

In addition to stealing time and those cigarettes from the gas station, he'd occasionally let his friends pump gas and take off without paying. He'd just report it as a drive-off. There were no cameras outside, so they always got away without issue. I heard him and his friends bragging about it.

God knows how much money the gas station lost because of him. He was lucky he wasn't sitting in jail for multiple felonies.

I tried to hold back my disgust, but it was impossible.

"You're so irresponsible. Do you have any idea how embarrassing it is that my fiancé would get fired for this? You need to do better, Jared. You're going to pay them back every dime, and you're going to get a new job immediately! Although I don't know how you're going to get one without them as a reference," I snarled. "God, what were you thinking!"

I'm really marrying a fucking idiot, aren't I?

"Babe, I'm really sorry! I'm going to shower up and go put in some applications now. I will make this up to you. I promise."

It was always "I will" with him. Forever promising to be better in the future but not doing a damn thing in the present.

■ ■ ■

I'd come home from my lunch shift at three, and he'd just be rolling out of bed, with no applications done. He'd claim he filled some out online, but I doubted it. I gave him access to my bank account so that he could purchase things that he needed while he was off the job. Key word *needed*.

I kept track of every dime I spent by balancing my checkbook the way Grams showed me. Imagine my surprise when I deposited $600 in my account, and my new balance read $715.23. With my $600 deposit, I should've been pushing $2,500. Where was all my money?

Unbeknownst to me, Jared was using my money to buy expensive emergency light bars to refurbish. I'm talking hundreds of dollars each. Although he did turn a profit on them, I never saw it or the money I'd unknowingly invested. I hoped he'd at least throw some my way to cover bills since he was robbing me blind, but he didn't.

After a few weeks, his brother Elliot called and said he was quitting the hotel and they needed a replacement. He told Jared he could easily get him the job. Lucky for Jared, he got it without even handing in a resume. Initially he started out during the day, which was nice because we had a similar schedule. Tensions had loosened a bit around the house without his joblessness hanging over our heads.

Not too long after, the person who worked the night audit left, and they offered him the position. He was making less at the hotel than he'd been at the gas station, and the night shift position did pay more. Plus, if he had his days open, he could spend more time at the firehouse and doing trainings, which was his real passion. Despite the impending doom I knew it would cause within our relationship, I encouraged him to take it.

His new hours immediately began to put a strain on us. I'd work doubles during the day, and he worked the nights. With a bit of luck, I might catch him for an hour between our shifts. But that was only if he actually stayed home to see me instead of going to the fire department to hang with the boys.

Things were weird with us. I'd text him during the day here and there while I was working, to try to maintain some sense of normalcy, but most

of the messages would go unanswered. Sleeping alone was so different, but at first, I enjoyed it. I could stay up reading for hours and go to bed when I wanted without being tortured by his snoring. He wasn't there to pressure me into sex when I was just trying to get a proper night's sleep. It was pretty ideal for me.

But after a while, I started to get suspicious of our lack of sex. He was someone who constantly needed it. Obviously, his new schedule changed things a bit, but if I knew Jared—and I did—he was still getting it somewhere. Jared constantly wanted it, begged for it, and insisted on it. For him to not to initiate sex during the few times he did see me was suspicious at the very least.

11

Another Christmas season was upon us. A time of year that used to be about family and happiness had become utterly meaningless to me. All I asked of Jared for Christmas was to put some money toward bills so I could buy my nieces a few gifts. To no surprise to me, he couldn't even do that.

He did, however, get me a journal to write in as a Christmas gift. I wasn't stupid; I knew this was a gift meant for him, not me. My walls were built so high at this point, they were impenetrable. I was impossible to read anymore. He thought if I got back into journaling, he'd have a way to keep tabs on me.

January was upon us, as dreary and gray as usual. The ditches were covered in dirt-speckled snow in a way that reminded me of cookies-and-cream ice cream. Winters in upstate New York have the kind of cold that really sticks to your bones. But I didn't mind walking home in the bitter temperatures anymore. It beat the frigidness I'd experience from him while he was home.

After the last New Year's, I knew better than to make my own plans. Not that he'd mentioned any himself. That night, we ended up going over to his parents' house to enjoy some family time. Laughable after him accosting me for wanting to spend the last New Year's with my family.

A few hours into the evening, Jared's pager rang out in a familiar tone. Like a good fireman's "wife," I knew the different emergency tones and approximately how long he *should* be gone. Although this was clearly a non-urgent call, he had to respond, since most of the other volunteers would be drinking that night. It seemed plausible to me.

"I'll be back soon," he said as he ran out the door with his untied boots clunking underneath him. I watched as his flashing lights disappeared down the street.

Six o'clock turned to nine o'clock, and next thing I knew, the new year was upon me. No response from Jared. No midnight kiss. I felt guilty for being disappointed. How could I be mad at someone who risked his life to help others? But I couldn't kick this suspicious feeling. Maybe he'd finished the call and then decided to hang out with the guys at the firehouse. But why didn't he respect me enough to let me know he was safe?

I fell asleep on the couch, and his mom covered me with a throw blanket before heading to bed herself. Two a.m. rolled around, and the Collins's goldens began to bark. I sat up just as Jared peeked his head in the door to say it was time to go home. He didn't offer any excuse, nor say he was sorry. He didn't acknowledge the weirdness of it all, nor ask how my night had been.

Next to him in bed, I couldn't help but notice the scent of Jack Daniels seeping from his mouth. *Weird.* My fiancé, the nondrinker, had gone out on an emergency call and returned to me intoxicated.

I don't even know who he is anymore.

Quality time didn't exist in our relationship. Even before smartphones took over our lives, he was constantly on his. Who was occupying his energy? Not like I knew. He told me it was a friend from the fire department, Hunter, but I knew better. Seemingly every month, he let a new girl's name slip from his lips. I'd take notice as he attempted to gauge my reaction. Who were they? How did they meet? It was all information I'd never be privy to.

Since he became a firefighter, it had been a constant issue for me that he refused to introduce me to his friends. The time he spent there consumed him, yet everyone surrounding him was a virtual stranger to me. I

could have stood next to one of them in the condiment aisle at Wegmans and not known. Jared and I were strangers living separate lives, intersecting once a day, then going about our business again.

I'd argue with him into the night about it. I feel like an accessory to him, a shiny one that's kept hidden in the back of the closet until the perfect moment arises for it to be shown off. Only his life was mundane, so in the closet I sat, collecting dust.

If I wasn't working, I was alone. I knew he was busy, and I understood how much training and time went into being a successful firefighter. But I was jealous. Jealous of something not even tangible. I couldn't tell him to choose me or the department. What type of person would that make me?

But I wasn't built to be alone. In solitude, we all start to go a bit crazy. My head was plagued with thoughts of a different life. The belief that the world would be better off without me became a primary belief floating around in my brain. At night it would call out to me, and many times I would have to hold myself back from responding. At least I had Libby to keep me company.

■ ■ ■

If I was ever a priority for Jared in the beginning, I sure the hell wasn't then. Some days, to get out of the doghouse, he'd insist on picking me up from work. I'd tell him the approximate time I'd be out, and he'd agree to be on standby. I'd message him as I wrapped up my last table, giving him plenty of time to get ready and meet me. Sometimes I assumed if I texted him early, he might come inside and visit. He never did.

Not only that, he rarely came to get me with any type of urgency. He'd show up anywhere from thirty to ninety minutes later. And to think I thought Chris was bad in this scenario. Ha. I wondered if he didn't want me walking home because he wasn't actually there like he claimed. Those thoughts plagued me constantly.

One evening I texted him for a ride, and he arrived forty-five minutes later. When he pulled up out front of the restaurant, I was in the restroom. I had tried to hold it because he was "on his way," but it got to the point

that I needed to go. A car pulled up behind him when he arrived, and he had to circle the block. A whole forty-second detour.

God forbid he actually parked the car instead of idling in the street.

When he circled back around, I was there waiting in the window like a good little girl. I got into his car and tried not to act annoyed, because I wasn't in the fighting mood. I wasn't greeted with the same enthusiasm.

It was a short ride home, but he screamed at me the whole way. He claimed I was disrespectful of his time because he'd had to spend forty seconds circling the block. My rebuttal was he didn't respect my time after making me wait so long for him, for the thousandth time. We pulled into the driveway, and I sternly stated, "I'm not going to fight about this all night. This argument is over."

The conversation might have been over, but my nightmare of an evening was only beginning. I walked in the door first, my back facing him. I slowly unbuttoned my herringbone jacket and went to place it on the hooks just inside the door. Jared shut the door, then just as quickly pulled my arm around my back and tripped me face first onto the carpet.

He sat on my back and placed his mouth to my ear. "You don't say when our fight is over," he whispered in a way I assume only serial killers do.

He sat up, still on my back, holding my head to the floor with his left hand. "Do you want a cupcake?" he asked.

I knew he wasn't offering a confectionary treat. He was disgusting. Just then, I heard him push out a long, rancid fart into his hand. I knew what was coming.

He quickly placed that hand, gas still inside, around my mouth and nose. "Breathe it in, or I'll suffocate you," he snarled.

Knowing I didn't have a choice, I did. I began to gag, and I puked in my mouth as he finally uncovered it.

"I'm sorry, did that not taste good?" he mocked. I looked back at him and watched in horror as he placed his hand down the front of his pants. "Here, let me wipe it off for you," he taunted as he took his right hand, now covered in ball sweat, and wiped it across my mouth.

In moments like this, I couldn't help but reflect on my past. What had I done so wrong in life that God would allow this suffering?

I felt the weight of Jared leave my back. I sat up on my forearms, forehead to the floor but still on my stomach. I was nervous that if I began to get up, he'd kick me. That was his favorite move.

That night, he didn't. Instead he rolled me to my backside and again sat on me.

"You're disrespectful and need to learn your place! If you're going to marry me, you need to jump when I say jump. This independent bullshit needs to end. Understood?"

I looked at him, emotionless. He repaid my silence by coughing up a loogie and slowly letting it drip down onto my face.

"Understood?" he repeated.

Again I refused to answer.

He pulled down the front of my shirt and bra, revealing my nipples. With one in each hand, he twisted them in opposite directions. Again and again. Harder and harder, yelling, "Titty twister!" My dry winter skin began to bleed, and instinctually I began crying.

I wiggled my arms loose from the hold his knees had on them and gouged his eyeballs. He backed up until I couldn't reach them anymore. I'd temporarily caused enough pain that he removed his hands from my breasts.

He placed his hands over his eyes and stood, wobbling. He was still wearing his tattered black steel-toed boots, and he placed one on my throat.

"All this fun is making me have to piss," he said as he unzipped his fly and pulled out his flaccid cock. He relieved himself on my face as I unsuccessfully tried to remove his boot from my neck.

When he was finished, he walked over to the couch, sitting to take off his boots. He grabbed the remote to turn on the TV as if the scene that had just gone down in our living room didn't occur. I peeled myself off the floor, soaked with piss and embarrassment. I made my way to the bathroom and let loose every tear that my body would produce. I was inconsolable, not that he cared.

Hours later he came in our room and lay next to me. My back was to him, but he took it upon himself to pull me close, poking his erection into me. Of course he was aroused by what he did. My stomach turned as I recoiled from him. I didn't reciprocate the affection and attempted to free myself from his grasp. Without care, he had his way with me.

I was certain that I would never allow him to have me again.

■ ■ ■

A few nights later, the temperature was in the teens. Snow was falling to the ground, twisting and rolling in the wind. Again I waited patiently by the picture window of the restaurant for Jared to arrive. I was the only one left in the building, which meant my lingering was holding up Nate, the bartender, from going home.

"You want a ride home, Jess?" he asked.

"That's not necessary. Jared's at the gas station filing up just a street away," I insisted. "I'll just wait outside."

I ventured out, braving the elements. I didn't move from the front of the restaurant until Nate passed by, honking with a wave.

Thank God he didn't press the issue, because there was no way I could let Jared see a man dropping me off. I was sure Nate knew I was fibbing. Night after night he watched as I stood at the picture window and waited an eternity for Jared to arrive.

I began the journey home, not bothering to message Jared and let him know I'd left. After an hour and a half waiting for him, I didn't owe him the decency. When I'd messaged with him, he claimed he'd spent the day at home with Libby, watching TV. He was lying.

I moved over the green metal bridge on the thirty-minute walk home, the wind desperately attempting to push me over. If only I'd known I'd be walking home, I would've grabbed my hat, mittens, and scarf. I regretted ever taking his word that he'd be there. *Fuck him for making me live on the other side of this stupid-ass bridge.*

As I neared the end of the bridge, I paused for the moment, dangling my upper body over the railing. The almost-freezing water was rushing

beneath, ice floating by now and then. I wondered if anyone had ever jumped from here. I wanted to jump. I wanted to end it all. But I couldn't give Jared the satisfaction of taking on the mourning fiancé role. I sighed, pulled my upper body back, and forced myself to continue walking.

As I cut through the frozen grass next to our apartment's driveway, I noticed his car was missing. *I knew it!*

I went inside, and aside from Libby, the place was deserted. Everything was in the identical place I'd left it. He was a slob; it wouldn't have looked like this if he'd been here all day. No dishes in the sink? He didn't do dishes, and he would've spent the day eating. *Suspicious.*

Suddenly my phone started blasting his ringtone. *Typical.*

"What?" I asked with attitude.

"Where the fuck are you?" he demanded.

"At home. Where the fuck are you?"

After a pause he said, "I was just there."

I lied and said, "That's funny, because I've been here for forty-five minutes." With the flip of my phone, I hung up on him. *Lying piece of shit.*

He had to be to work in a few minutes, so I knew he wouldn't be coming home. Over the next few hours, he called several times. I didn't answer. Continuous texts were blowing up my phone, which had long ago been placed on silent.

"I was home, but I stopped at the store. It took a while because they had a new cashier," read one excuse. He went on and on.

He just couldn't help digging himself a deeper hole. Adding irrelevant details no one would care to remember, because he was trying to make his lie seem realistic. Dumbass. If he were smart, he'd have told me, "I was actually at the station all day. I don't know why I lied." I would've accepted that. But he was an idiot.

Three a.m. came around. Libby and I were dead asleep in our bed when we heard him burst through the front door, slamming it without care for anyone else inhabiting our building.

Fuck. He was pissed.

The bedroom door flew open with the same ferocity. Quickly picking up his laundry basket, he began stuffing clothes into it. I could tell from

his body language that I should tread lightly. I slowly inched myself to a seated position, watching him.

He turned around and with all his fury yelled, *"This is the last time you ignore me, you stupid cunt."*

Oh, how shocking. He'd left me stranded, to walk in the freezing cold, straight up lied to me several times, and *I* was the devil for ignoring him for a few hours. Classic Jared.

Love is a weird thing. When I was young, I always searched for a finite definition of "love"—you know, something to hold onto. With little clarity on the meaning, I began to fill in the blanks myself. My meaning of love could be interchanged with the meaning of volatile. I didn't know how to love or accept love of any other form. To me, our relationship dynamic was almost normal. He'd act this way, and each time I'd beg him to stay.

I pleaded with him to stay with me. And in that moment, I meant it. Perhaps I wanted him to stay because I'd become dependent on him. It's strange to think that I could've been dependent on someone who was so undependable, but I was. I felt if he left me, I would die.

Jared eventually calmed himself and agreed to stay.

We never had any discussions about where he *really* was that day. But I think that was the point. I'd caught him in a lie, and he'd orchestrated this massive show to distract me from the original issue. His deflection worked.

I still hated him.

12

January was the longest month of my life. After the last assault, I was numb. My stress level was at an all-time high. Every time he was near, I walked on eggshells.

As I mentioned before, I wasn't on birth control. Jared refused to use condoms, but he usually would pull out. The night he took it upon himself to fuck me, he didn't bother pulling out. He knew I had one foot out the door, and he assumed giving me a baby would make me stay.

The day I was supposed to start my period arrived, but my period didn't come. A day late isn't worrisome to everyone, but my period was always on time. Jared, controlling man he was, had my ovulation schedule down pat.

The following day at work, I received a text from Jared: "Why aren't there any tampons in the garbage?"

"Ugh, you're gross for even looking," I responded.

"I'm not having a fucking kid with you, Jess. How many times do I have to tell you! You did this on purpose, I know it. If you're pregnant, it's over. I swear I'll throw you down the fucking stairs before I have another kid."

Another kid. Ha. There it is.

"Okay," I replied and went back to work. I figured I could use this as a way to get away from him, but I was sincerely terrified. *What if I really am carrying his child?* I'd never been pregnant before and never had to think about the what-ifs. Maybe I'd kill myself to save him the hassle. Or have an abortion. Moving to a commune and raising the child without a word to anyone also sounded nice. All I knew was, if I was pregnant with his kid, I was as good as dead.

I went to the restroom and punched myself in the uterus over and over as hard as I could. If I was pregnant, I was only two weeks along. Maybe I still had a way out. I know some of you are reading this damning me to hell. But until you're sexually assaulted and possibly impregnated by your abusive, sadistic fiancé, I don't want to fucking hear it.

After work, I decided to drag Nate over to the Gaffer to get completely inebriated, despite being underage. I chugged pint after pint of Blue Moon and did shot after shot of Patrón. I was going to use this liquid courage to confront him at work and tell him what the fuck was up. I wouldn't be with someone who refused to have kids with me, and if he didn't want them in his future, it was completely over. I knew he'd never have kids with me by choice. So this ultimatum was more or less me giving him the power to end it.

I decided I'd talk to him at work because it felt safer. No other employees worked at night, and I didn't think he would leave the hotel unattended again. It gave me a bit of a window to figure things out.

I dialed a cab and chugged the last of my Blue Moon. I asked the flirty bartender to do a shot of Patrón with me and Nate, and to get my tab. After tipping him a generous 30 percent, away I went in my cab.

"Can you drop me at the hotel?" I asked the driver.

"Which one?"

"Ya know, the hotel," I slurred with no further clarification besides pointing in its general direction.

He dropped me off, and I stumbled across the parking lot. I spied Jared standing out front with a short, very blond girl. She appeared my age or younger. *Well.* She wasn't the typical guest for a small hotel in Corning

in the dead of winter. It wasn't exactly tourist season, and she didn't come off as someone who was in town on business. It was also fucking one a.m.

At first, they didn't notice me, but I was still out of earshot. I hardly moved as I observed them from afar. Their energy was too comfortable, and flirtatious. They were standing far too close to be strangers. *He's looking at her like he used to look at me.*

Suddenly she saw me out of the corner of her eye, and from where I was standing, she appeared panicked. I began to walk toward them, and as I got in hearing range, she quickly took off toward her parked vehicle, not looking back. She had a New York license plate unlike most of the others in the parking lot. *Hmm.*

I was surrounded by a thousand waving red flags, but I was too drunk to see their meaning.

"Jared…who was that?"

"Ugh, how should I know?" he replied.

"Well, you seemed to be in quite the lengthy conversation. What was that about?"

He looked at me with a blank stare. *I'm too drunk for this.* But I wasn't ready to let it go. "Is she staying here?"

"N-n-nooo," he stuttered.

"Okay, then care to tell me who the woman I just caught you talking to with googly eyes is? What the fuck was she doing here, Jared?"

"I don't know. I guess she was lost and was looking for directions."

"You guess? Were you not part of the conversation?" I began laughing hysterically. "Directions to where? She had to pass by several hotels and gas stations off the highway before arriving here. Plus she has New York plates, so she's probably a local."

"Wooooow. You're so drunk right now. Look at you making up all these bullshit accusations to try to take away from the fact that you're fucking wasted."

He was right; I was wasted. "I haven't even accused you of anything. I'm just pointing out how unlikely your story is. Anyway, we need to talk."

"I'm not talking to you like this."

"Well, guess what, Jared, you don't run the show. You can choose not to respond, but I'm talking. It really fucking gutted me when you said you'd leave me if I'm pregnant. I've asked you repeatedly to use condoms. You refuse to, despite knowing I'm not on birth control. You already have one kid; you know how this works. You claimed you'd hurt me if I was pregnant, and that's fucked up, since it would be your fault. I'm here to tell you I'm not ready to be pregnant. I don't want a child this instant, but with absolute certainty, I will be a mother one day. With or without you. I'm asking you, because I can't waste any more time: Do you see yourself having children with me?"

I waited in anticipation for him to say no.

"Babe, of course I want to have children with you. I was taken off guard earlier is all. There's no need to be upset. Now have a seat, I'm calling you a cab."

I sat there completely dumbfounded. That hadn't gone as planned. I'd had this conversation in my head a thousand different ways. I never anticipated him answering that way. I was pretty sure he was lying, but how could I be certain?

The same cab that had dropped me arrived to pick me up. Jared put me in and kissed me on the forehead. As the car pulled away, so did my chance of leaving.

About a week later, I screamed in delight inside the work bathroom stall, as I'd finally started my period. I'm sure I was late because I was stressed. Thank God for this experience, though, because it showed me the true Jared. The Jared that I was sure both Ashley and Tori had seen many times. I felt bad for them. Shit, I felt bad for me.

Speaking of Tori, she had her child. After the whole order of protection debacle, there was a court-ordered paternity test, since she was requesting child support. Turns out Jared wasn't the father after all. I was floored! That was probably the luckiest fuck-up she ever made. Anyone would've made a better father than that monster.

■ ■ ■

Incoming call from Jared. *Great. He only calls me when he's mad.*

"Hello?"

"Babe, we need to talk." He sounded distraught.

"Okay?"

"So I just wanted to tell you something before the rumor mill starts and gets out of control. You know how yesterday I said got Wendy's with a few of the boys from the firehouse?"

"Yes…"

"Well, Brianna came too. It's no big deal, of course, but my ex saw me driving with her in the passenger seat. I know she's going to try starting some bullshit. But I swear that's all it was. We all got Wendy's, and I dropped them back off at the station. That's it…Are you mad? I don't want to lose you."

"Calm down. Do you really think I'll just up and leave because of a rumor started by your ex? You already mentioned you went to Wendy's with people from the firehouse. So no. I'm not mad. I appreciate you actually giving me a heads-up about it."

"So you're not mad?"

"No. Should I be?"

"Definitely not. I just wanted to be sure."

After hanging up, I kind of started to feel bad for him. I hated that he felt he couldn't tell me the truth about girlfriends. My insecurities got in the way of our communication, and I hated myself for it. He actually sounded scared that I'd leave him because a girl was in the same group with him eating. I really didn't want to be a crazy girlfriend anymore. *Why does he make me so crazy?*

13

February 9, 2009. It was as normal of a day as any other. I spent most of it puttering around the house while Jared was at the fire department. It was a Tuesday—Jared's training day. Since he was away those evenings, he allowed me to have some girls' time with my work friends. Yes, allowed.

I'd been sitting on the couch for hours, scrolling through my Facebook feed, music blaring in the background, when I suddenly remembered I'd forgotten to get my laundry from the dryer in the basement. *Shit.*

Out into the hallway I ventured, past the front doors and down to the scary laundry room. The basement smelled like a mixture of mildew and stale cigarettes. I quickly threw my clothes back in the basket, flipped the light switch off, then ran like hell down the creepy hallway. Every time I ventured into that basement was one time too many.

As I got to the top of the landing, I peered into my mailbox, which was affixed to the wall. My eyes were assaulted with familiar stark white envelopes, which of course were nothing other than bills. I grabbed the pile of envelopes, plopped them on top of my colossal pile of laundry, which was drooping from the basket, and continued to our apartment.

I folded each item carefully, concentrating on the method. I don't know where I learned to fold in this manner. Neither my mother nor my

grandmother fold clothing in this way. I guess it's one of those individual habits that attaches itself to you when you mature.

After quite some time, I got to the end of the basket. I was thankful I didn't have to touch another pair of Jared's shit-stained boxers until next laundry day. What kind of grown man can't properly wipe his own ass?

I looked at the white pile of envelopes sitting beside me. Now was as good a time as any to open them. I took the handful and walked into the kitchen, grabbing the marker from the dry-erase board that was hanging right inside the entrance. As a habit, I would go through one by one, writing the amount due on its due date. It was a financial habit Grams taught me early on.

I looked at the sender of the last bill, Verizon. I almost tossed it directly into the bin, as the total and date never changed. But that day something told me to open it. I ripped open the top of the envelope with my kitchen shears, also the way Grams taught me. When I unfolded the paper, I was mildly surprised. It was more expensive. Nothing big, only around five dollars, but enough for me to look into it.

Ugh, probably some shit Jared had downloaded or something. Always on my dime, of course. After beginning at the Brew Pub, I decided it was best to open my own cell phone account and get off Chris's. After a year or whatever time had passed, I figured it only made sense to sever that tie.

It was also a gift to me, as it shut Jared up for a whole five minutes. I constantly overheard Beth and him arguing about his portion of the family phone bill, which he seemingly never paid on time. Typical Jared. He begged me to add him to my plan, because naturally his credit was already fucked. It should've been a red flag for me, but I figured it made sense to have an account with my husband-to-be. He never contributed a dime to it, of course. Add it to the list.

I made myself a cup of coffee and watched the french vanilla creamer swirl as I poured. Once it was a nice shade of white, barely resembling coffee, I headed to the living room and sat back into the couch.

I opened Jared's laptop and began searching for a recipe to make for our upcoming Valentine's dinner on Saturday. I decided to splurge and make a lasagna. *Please, God, let me have my mother's cooking skills.*

Just before closing the computer, I remembered the bill. I pulled up our Verizon account, unsure of what I was looking for. I retrieved the prior month's bill and compared it line by line to the current invoice. There was the issue, just some random added charge. I dialed the help line on the paper bill, and they quickly stated they'd credit my account and apologized for the glitch. Easy peasy.

After hanging up, I scanned our account, and something else caught my eye. Jared constantly accused me of being on my phone more than he was, so why were his texts and phone calls outnumbering mine? By a lot? If they were slightly higher, I wouldn't have thought twice, but three times higher? That was a red flag for sure.

I was about to close the laptop when a bad idea came to me.

I need to know. Who was he texting? Who was he calling? He always claimed it was Hunter, but come on. Why would some middle-aged man spend his days and nights messaging my fiancé? Jared wasn't even that interesting. Suspicious. Though, when his phone went off, it did read "Hunter."

At first, I didn't even know what I was looking at. But all the evidence was right there in front of me. All I needed was that one tip to crack it wide open. I felt like a detective on TV, sifting through evidence, trying to solve a murder. Little did I know I'd be murdering my relationship that day.

I saw the same number repeated over and over as I scrolled. Calls, texts. Lots of them. Still, this didn't tell me anything. I inspected the times of the interactions. There had be something here.

Oh yeah! Yesterday around eight p.m., his phone had gone off, and it read "Hunter." He was smiling at his phone as he was texting back. Strange, because Jared didn't smile often. I needed to find that text. *Found it.* Eight p.m., that same repeating number.

I scrolled further. Two a.m. phone calls while working, lasting an hour? Constant texting until four a.m.?

Yeah, sure that's Hunter.

Jared was either lying about whom he was talking to, or he was having an affair with Hunter. I sat there feeling like a heavy weight had been

plopped on my chest. I had no proof of anything though. *I guess I'll file the phone number away in my brain for later. Maybe I'll get drunk and dial it.*

I looked to the lower right corner of the computer. It was four p.m., time for me to get ready for girls' night. As I warmed up the shower, I walked into the spare bedroom to file the Verizon bill. There was a random pile of papers sitting there, and hating clutter, I decided to glance through it quickly.

Jared didn't even realize what he'd done by leaving those papers there. Right there, sitting on top, was the roster for the fire department. Next to each name was their title and their phone number. My eyes quickly explored the pages, looking for one name, Hunter. Bingo.

Wrong number.

Wait, what if this was an old number? It could be a roster that wasn't updated. No. These papers definitely weren't there last week, and the new volunteers' names were on it too. It was accurate. I still didn't know who the mystery number belonged to.

I couldn't leave him without tangible proof, could I?

Frustrated, I threw the paper toward the table; it floated down, missing the table, and landed on the floor. As I bent over to grab it, the number stuck out to me like it was magnified. *There it is! You've got to be fucking kidding me.*

Brianna Williams.

I should've known. How could I have been so stupid? So dumb to think that he could possibly be around a woman, regardless of setting, without trying to get into her pants. What a scumbag. I wasn't content with our relationship, and yes, I wanted out. But I still felt betrayed. *How can he walk inside our home, night after night, knowing what he's doing to me? What is he even doing? Hell if I know!* But my imagination ran away with ideas.

At that time, it all came rushing to me. All of those red flags began adding up. So that was why he wouldn't introduce me to anyone at the fire department. I was sure they all knew about his sidepiece. Did they even know about me? He was always leaving the room when his phone rang and speaking in a whisper to whomever was on the other side. "Bill collector,"

he'd claim. The mystery blonde at the hotel the night I stumbled there—could that have been her?

Jess, come back to reality. You need to get in the shower. I shook my head as I walked into the bathroom. Slowly, I removed my clothes and stared at myself in the mirror. What was so bad about me? I felt so dirty. All the times he touched me, all those times he was inside me. No matter how tumultuous our relationship was, this betrayal cut deep.

In the shower I went; the water was too hot on my skin, but I didn't bother adjusting it. I need to feel, to feel something. I stood there in the scalding stream of water, wanting to die.

I needed to find a way to leave him, but safely. I know you're probably sick of reading that, time and time again. I was tired of thinking it too.

I knew how impossibly dangerous it would be to escape. He'd already tried to kill me. I'd read many articles on leaving an abuser. They always contained the same ominous warning: abusers become more dangerous when you attempt to flee. Even the wording there—"flee," not break up. It was like I was trying to leave the country—which wouldn't have been a bad move at the moment, if I'd had connections. Hell, I knew from experience there was *no* way he'd accept me breaking off our engagement and kicking him out. It didn't matter if there was another girl or not; we weren't done until *he* said we were.

I knew once I presented him with what I found, he'd claim it wasn't evidence that he cheated. He'd accuse me of trying to force puzzle pieces together that didn't fit. He'd tell me I was making myself look stupid. That I must've been digging for a reason to leave him. Manipulators are relentless in finding a way to make their problems seem like they're yours. He always gaslit me in this way, which is all too common of an occurrence in abusive relationships.

Hmm. There has to be something.

That was when I remembered. A few weeks ago, he'd received an irate voice mail from another man—his opponent in the race for the captain's position in the department. He felt Jared wasn't qualified, and their differences were causing a rift within the department. Standard politics, but it was all Jared could talk about.

When he'd first listened to the voice mail, he had the volume up a little too loud for not knowing what the caller might say. Jared listened as the man screamed obscenities into the phone for a few minutes. I recalled hearing him say something about "don't think I won't tell your fiancée about her!" *Strange*.

Jared later replayed that voice mail to me on speaker, trying to get me to see what a piece of shit the other guy was. Honestly, I didn't think Jared deserved the captain's position, and he knew it. This was his last-ditch attempt to show me how much "better" of a candidate he was. Sure. Seemed to me neither of them was qualified for the prestigious position, but what the hell did I know?

Anyway, when he replayed me the message, he cut the voice mail short before the man got to the part, I felt was suspicious. Doubling down on the suspiciousness.

I confronted Jared about what I'd heard before, and he accused me of being crazy. Initially he denied I'd heard it at all. But I knew I did. When I insisted he play the voice mail in its entirety, if he had nothing to hide, he threw a fit.

"Clearly this man hates me and is trying to ruin my life. You can't take anything he says seriously." Judging by the rest of the voice mail, it seemed plausible. So, like many other things, I let it slide.

Now I knew what this voice mail was referring to, and I was going to create a lie around it. I didn't feel the least bit guilty bringing this guy down into the fire with me. He seemed like a prick.

I would tell Jared the man found me on Facebook and sent me photos of Brianna and him cozied up at the firehouse. I didn't know if any such photos existed, but Jared didn't either.

Shit, I'm so distracted. My ride will be here any minute. Pull it together. I quickly finished getting ready for the long evening that was ahead. At least I didn't have to worry about walking in the cold.

My coworker Jennifer, a bubbly Italian, was on her way. She was always down to pick me up so I didn't have to walk in the cold. Though I felt like I could talk to her about nearly anything, I kept a veil over my situation.

Despite my efforts, she knew my relationship was a hot mess. She prayed I'd leave Jared, just like everyone else did.

My phone buzzed; she had arrived. I paused by the kitchen table, slowly pulling the small diamond ring from my finger. I held it in my right hand, staring at it one last time. All the diamonds in the world couldn't fix this. I placed the ring on the table and backed away slowly.

When I got into Jen's car, I let it all go. I confessed all Jared's dirty secrets I'd uncovered. All the red flags that had finally come to light. How betrayed I felt. All of it. I told her I was finally leaving Jared. For good this time.

"I know you probably don't believe me. Under normal circumstances, I probably wouldn't either. But this time I can feel it in my heart. I'm done," I declared.

Abuse I can heal from. I think. *But an affair is something I just can't get past.* The betrayal, the endless lies, the broken trust. It was much more personal. Each time I began to catch onto him, he'd label me as crazy, and in the process, I became exactly that.

My mind was made up. He didn't deserve a face-to-face breakup. I didn't owe him shit. Now that I wasn't at home, I could text him. I was physically safe.

My stomach was in knots as I pulled my phone out of my gaudy red-and-black zebra-print purse. I knew he was "in a training" at the moment, which was probably code for in *her.* Either way, if I messaged him now, it would probably be a bit before a response.

"I know about Brianna, and I don't want to hear your bullshit excuses. You've been cheating on me for a while now with her, and we both know it. It's all in the open now, I finally have my proof. I left the engagement ring on the table. Take it. I don't want it. Get enough of your shit to get you through a few days at your parents' house, and we'll arrange a time later for you to get the rest. If you put up a struggle with this demand, I'll be forced to call the cops, and I know that's something your status at the fire station can't afford."

Send.

I placed my phone on the bar and sighed with a sense of relief. This was it. I was finally leaving.

Buzz. Text message from Jared.

"What are you talking about?"

The new sense of relief flew far, far away and was replaced with anxiety. Of course he was playing stupid. He didn't know what I'd found.

"This isn't a discussion. Please respect my decision. I don't care if you stay with your parents or your new girlfriend, but you're not welcome at my house."

Incoming call. Jared.

Ignore.

Incoming call. Jared.

Ignore.

I stared at the bar, chugged the pint in front of me, looked up, and quickly asked Nate for another. I turned to my friends, who were watching me in astonishment, and filled them in on the details of my day. Each gave me their condolences, seemingly sympathetic but not the least bit shocked.

I was beyond thankful to have those girls there for support. It didn't matter how many times I pushed them away. They always stayed. They understood.

"I'm scared. Did I do the right thing? What if he comes after me?"

"Oh, he won't do that. He's not that stupid," said Jennifer.

But they didn't know him. They didn't have a clue.

It was a chilly winter evening, which meant a painfully slow night for the pub. The chefs were out at the bar, chatting with us as well, a few of them sipping on some beers. David, head chef and manager, knew a lot about Jared and our relationship. For some reason I felt comfortable confiding in him. He knew I was scared.

"Jess, don't worry. We've got you. If he comes in here, you go to the kitchen immediately. I'll make sure he leaves."

"What if he won't? Or worse, what if he causes a scene?" I questioned, worried the owner would fire me.

"Then we'll call the cops. But you're safe here. Don't worry about it."

That brought me a minuscule amount of momentary relief. But what about when I got home? *Maybe I should ask Pete to stay over,* I thought. *No. I can't drag him into my shit again. He deserves better than that.*

A few customers had trickled in at this point, so the cooks went back to their station. The girls and I were on our appetizers when suddenly I felt a familiar cold breeze creep up my backside. Anytime the front door was opened, it created a vacuum, pulling out all the warmth. I didn't have to turn around. I knew it was him.

Without making eye contact, I tried to get down off my bar stool to head toward the kitchen. It was too late. I'd never seen him move so fast.

My terrified eyes met those of the elderly man who was in a nearby booth, trying to enjoy a nice dinner with his wife. Jared grabbed my right wrist, and with a familiar twist and pull, he had me turned around facing him, nearly knocking me off my feet. He was down on one knee now. I did my best to avoid eye contact, gazing directly above his head. He knew.

"Jess, please don't do this. Look at me."

No way in hell.

"Fine, you don't have to look at me, but I know you can hear me." I stood there frozen, unresponsive. I knew everyone was watching the show.

"Babe, I know I messed up, but we can fix this. I'll do anything to..." He continued his pleading, but I was no longer in the position to listen. I knew he was holding my engagement ring. It further fueled the angry flames inside me. I would not open my fist and allow him to put it back on.

It suddenly hit me. I didn't need to subject myself to this nonsense for one more minute. He wasn't in control. This was my turf, and these were my people. I looked over at Nate and his heavily tattooed muscular arms and gave him a "help me" look.

Nate spoke up. "Look, man, she doesn't want you here. I think it's best if you leave."

At that moment I ripped my hand out of his and bolted for the kitchen. The short distance had never seemed so long. I doubted he'd beat me down in front of all these people, but he was an animal who'd lost control. He was unpredictable.

I don't know why, but once my feet hit the other side of that kitchen door, I started bawling, and hard. The kitchen staff knew what had happened without my saying a word. They flew around the small island that

made up the restaurant's kitchen and exited quickly as my girlfriends took turns hugging me.

I felt so mortified. Never did I think he'd come here. Not once had he come inside the entire time I worked here. One of my friends didn't even know it was him, that was how much of a ghost he'd been in my life. Nonexistent. It was almost as if *I* was the other girl.

After less than a minute, the chefs came back in the kitchen.

"He's gone, there's nothing to worry about anymore. Just enjoy your dinner. He won't be back," promised David.

I wasn't so certain.

I tried to continue on my girls' night as if nothing had happened. I'd become accustomed to faking it with ease. With ruined makeup, I ate, drank, and laughed along to every joke with as much normalcy as I could muster.

As the night wound down, I knew I'd have to face going home alone. Sans bodyguard.

Once Jenn dropped me at home, uneasy feelings of regret and uncertainty began to rear their ugly heads. Had I done the right thing? I was going to be alone forever now, unlovable. I was a broken toy, and no one would want to fix me. The benefits of being with me weren't worth the effort it would take to climb my walls. I had nothing to offer a man besides my body, and even that was a work in progress.

I knew he was a piece of shit, and abusive. I had suspicions that he'd messed around on me. Many. I'd catch him in lies and awkward situations, but he would always gaslight me. Every time, I would focus on something else and allow it to fog over my suspicions. I couldn't believe he actually did it, though. All the lies, the abuse, the secret child—I went through it all with him. It sounds stupid, but at the time I deemed those unworthy reasons to leave him. I'd revealed to him on many occasions that the only way I'd ever truly leave him was if he was unfaithful. He was testing me.

The internal fight was destructive. *What proof do I have? A call list, a name, a number, and a million red flags. Have they hooked up yet? What does she know about us? Maybe they are just really good friends. Had I really given up our whole future and publicly embarrassed him over a gut feeling?*

What if I was wrong?

No. I couldn't ignore the mounting issues anymore. For years he'd called me fat after the weight I gained being with him. He'd compare me to others, asking, "Why can't you look like that?" *Like he is some prize to look at.*

I'd begun going to the gym a few months ago and lost thirty pounds to impress him. I spent two hours a day there. It'd relight our spark, I convinced myself. He didn't even notice the change. The girl at the hotel that night, she was the exact type he always told me he wanted me to look like.

Jared had the worst style of anyone I'd ever met. He wore black cotton T-shirts that were worn down to oblivion, so small they exposed his protruding hairy belly, the color so dull it could hardly be considered black. Or to mix it up, he'd wear his blue logo shirt for the fire department, which his friends always nagged him about. He paired it with the most unimpressive khakis or carpenter jeans in a shade of blue I didn't realize jeans were made in anymore. The cherry on top was his shitty black nicked-up steel-toed boots. It was a lucky day if he tied them instead of clunking around in them untied. His hair was black, all buzzed to the same length, except where he'd started balding on each side.

Honestly, he was lucky I ever looked twice at him. But I wanted to be attracted to my fiancé. I wanted him to put in some effort too. I bought him a new wardrobe of sexy sweaters and button-ups, ones that complimented his body type. I gave him properly fitting, light blue, slightly tattered American Eagle jeans. I got him to try on them on once. Seeing him in clothing that suited his current body allowed me to remember why I was attracted to him.

But of course, for months they sat in his dresser, unworn. I even purchased some tantalizing cologne and styling product for his hair. I convinced him to use them once, and I tried to emphasize how great he looked and smelled. But he didn't get the hint. He refused to wear any of the clothes or do anything with himself.

Except, however, on nights he went to the firehouse. I didn't think much of it at the time. I assumed he was just trying to look professional because he wanted the captain position. But now I saw it clearly: he was

trying to impress her. I was sure it had worked. She got the version of him that I'd put together, the one that I built. I didn't know her, but I hated her for having a version of him I wasn't allowed.

I knew this wasn't her fault at all. Despite feelings of hatred, I couldn't be mad at her. She could be a home-wrecking whore, but if Jared really cared about me, that wouldn't have mattered. She didn't owe me a drop of loyalty, but he did. As far as most of his firehouse crew knew, I didn't exist. Even his social media didn't give away much. Knowing his secretive tendencies, I figured she likely didn't even know who I was. But he did. If she did know about me, he probably claimed we weren't together anymore. He had likely told her I was a crazy ex that couldn't take a hint.

He knew what this would do to me, and he chose to do it anyway.

14

In the immediate days following the breakup, Jared fell off the grid. I didn't know where he was staying or who he was with. I wondered what his family did or didn't know about our demise. If I were a betting a girl, I'd bet he was shacked up with *her* somewhere. I'd spent my days working and nights crying into a growler of high-test porter. I wasn't particularly crying over the loss of him. I was crying over the loss of myself. The loss of the only life and identity I knew.

I started hanging out with different people who, thankfully, enjoyed drinking as much as I did. I needed that at the time.

Nate, the bartender from the pub, about ten years my senior, and his beautiful, tall, blond girlfriend Leah, took me under their wings. She was my age. At first, I was intimidated by her, as I usually was by gorgeous women. But one day she came into the pub after drinking some wine, and she gushed about how pretty I was. Honestly, I wasn't used to being flattered by others anymore, so this made me feel human again. I accepted that I needed a proper girlfriend in my life, and after that day we were joined at the hip. She and Nate didn't mind that I tagged along as a third wheel—they actually insisted on it. I was appreciative.

A few months before the death of my relationship, I'd started to take an innocent liking to one of Nate's friends. One of those situations where

you acknowledge someone is both physically attractive and a good person, but you'd never act on it. He'd come in every day after work and drink down a bunch of Ketel One. He'd always compliment me on my progress in the gym, and I was happy someone took notice. I enjoyed the mindless flirting at first, since I wasn't getting it at home. I guess the need for men's attention has always been a bad habit of mine.

His name was Lee. He was handsome, fit, clean cut, energetic, intelligent, and successful. A real man; he was the complete opposite of Jared. He'd recently moved to our area from Connecticut to work on helicopters. Other than that, I didn't initially know much about him.

I guess you could say I'm one of those women who just can't be happy alone, because the week I left Jared, I found myself gravitating toward him. Predictable of me, I'm aware.

I came to work with a black-and-white flower in my hair, really self-conscious about my new fashion statement.

Lee came in as usual, and upon seeing me, he said, "Love the flower. It's sexy."

Naturally, flowers in my hair became a fashion staple for a while to follow. Anything to grab his attention—I lived for it.

On weekends I'd bartend, and he'd sit there with me, bantering back and forth my entire shift. I loved talking shit with him and could feel the real Jessica starting to reemerge.

It was easy to throw myself at Lee, because Jared made this first week apart seem simple. It was as if we'd never existed at all. Maybe he was actually allowing me to leave without a struggle.

But soon enough, the text came in. "Jess, I know you don't want to see me. But I have to come over and get some of my stuff. When would be a good time?" Jared asked.

"Tomorrow between 12 p.m. and 2 p.m.," I responded. I knew I wouldn't be home from work until about four, so that would allow us not to cross paths. I thought.

At four p.m. I came strolling up the drive with my Espresso Mocha Madness from Soul Full Cup in hand. I was in a chipper mood that day, despite the dreary weather. Nate and Leah had invited me to their house

for a party later that night, and Lee was sure to be there. It would be my first time being around him outside of work, and the temptress inside me was elated.

I reached in my purse to search for my keys, and that was when I noticed his SUV parked toward the back of the lot. *Ugh, I knew this was too good to be true.* I froze. *What I should do?* My eyes darted from his vehicle to the apartment to the road. I knew I should probably leave, but he'd just wait here as long as needed.

I reached for my cell phone and texted Leah. "Just got to my house, and Jared's here. If I die, you know who did it haha."

I needed to add the haha because while I was serious, she only knew a few dirty details that I let escape after sharing too many bottles of wine. The severity of this situation would be lost on her. I shuddered briefly as I was bombarded with the memory of my previous attempt to flee.

I shook it off as I walked up the stairs to my apartment, head held high. *I can handle whatever is about to happen.* Stupidly, I put my key into the already unlocked door. I turned the handle and placed myself in my doorway in a very cocky stance. He sat at the dining table, located on the opposite side of the room. His posture was laughably aggressive.

Before I could say anything, he asked accusingly, "Thought you got out at two p.m.?"

"And I thought you had a new bitch to be inside of. Time for you to go," I clapped back as I stepped aside and pointed to the hallway.

He stood up, violently grabbing his laundry basket, and tried to pass by me. I put my hand across the doorway, stopping him, and sternly demanded, "Nope. Give me your key."

Jared rolled his eyes before reaching his hand into his pocket, divulging a single key.

"I'm not stupid. I want the one on your keychain too." I could see all the blood in his body begin to boil, and his breathing became heavy. He threw his laundry basket to the floor and struggled to remove the key from the ring.

"This isn't over," he threatened as he chucked the key over my shoulder. *Whatever.*

I watched him as he left the building, slamming the main door. I waited for his SUV to fly by the windows before going back inside. Small victories. I hoped that was the last time I ever saw him.

I powered up the new pearl-white Sony laptop I'd recently purchased for myself and went to YouTube. *Alanis Morrisette will get me through this; she always does.* I opened a bottle of Red Cat, poured it to the very top of the glass, and took my frustrations out on my kitchen with a scrubby sponge. *I love living alone.*

That night I went to the party looking and feeling brand new. The day before I'd gotten a fresh haircut and colored my hair dark brown with blond highlights. Any woman who changes her appearance after a breakup is ready to fuck shit up. She's all the way done.

As I opened the door and peered around, I realized I didn't know anyone at the party aside from Nate and Leah. They were talking to some people I'd never seen, but nevertheless, I was happy to be out. Thank God I'd drunk all that Red Cat. I didn't feel as awkward as I normally was.

Moments later the door opened, and Lee entered. I could feel the energy of the room shift. His blue eyes immediately caught mine, and he quickly moved through the crowd, making his way to me as if no one else were there. He was well put together as usual and smelled like adventure. I made it my mission to have him. I had a feeling it wouldn't be too hard.

He had a habit of making me feel like I was the only person in the room who mattered. He'd guide me by the small of my back and move me out of the way by my hips. He was ever so gentle as he brushed the hair out of my face, looking at me with his crystal eyes. I was so smitten by him. But I still needed to be cautious.

We played a few drinking games with the rest of the party, being partners when the game allowed. I sucked, but I wasn't there for the games. By the end of the night, we were drunken fools, kissing and heavily petting. This was exactly what I needed. We exited the party at the same time, and while on the street we called cabs to go home to our own apartments. Our joint departure would surely have sparked a rumor or two. He waited with me as mine arrived and shooed me away with a goodbye kiss.

Jared had cautioned me that no one else would ever want me, but boy was he wrong. I smiled on the short drive home, but I couldn't help peeking into the hotel's parking lot as I rode by, searching for Jared's car. I snapped my neck in shock to stare at his empty parking spot. Had he maybe taken the night off?

The taxi dropped me off at the end of my apartment's long driveway. I stood there digging in my messy purse for my keys. *Wow, I'm wobbly. I can't do this standing.* I placed my purse on the ground, squatted down, and started sifting through it. *Why do I have so much random shit in here?*

Just then I became blinded by headlights. I raised my arm to shield my eyes. I still couldn't make out the car. *That's unusual. Why's someone leaving my driveway at this hour?*

I heard the squealing tires as the driver hit their accelerator. They were speeding right for me. I jumped out of the way in time, leaving my purse where it sat. This was intentional.

"*What the fuck!*" I screamed.

As the vehicle flew by just centimeters away, I caught a glimpse of the driver who'd attempted to end my life. They rounded the corner of the drive, screeching their tires because they didn't stop, and quickly gassed it down the street. I stood there with my mouth wide open.

It was him.

I'd half expected a text from him, something angry or hurtful. But I'd gotten nothing. I didn't know if it made me feel better or worse that I hadn't heard from him. Now I was tempted to message him. I crafted half a dozen angry messages threatening him, only to erase them before ever pressing send. What is there even to say to someone you used to love after they just tried to take your life? *Again.* I should've reported it to the police, but he knew I wouldn't. Eventually, the mix of alcohol and sadness took over, and I fell asleep.

The next day went as usual. I worked in the morning and brought a growler of porter home to enjoy while I watched trash TV and cuddled Libby. I drank the entire growler myself, which was about the equivalent of drinking a bottle of NyQuil. I fell asleep on the couch and awoke at one

a.m. seriously having to pee. "Time for bed, Libby," I said as I carried him down the hallway, stumbling. I used the bathroom, then headed into bed.

It might have been three a.m. when I suddenly awoke. Not because of a sound, but rather a feeling. I felt like I was being watched. Still lying on my side, I opened my eyes. I couldn't kick the heavy gut feeling that I wasn't alone. Quickly, I flung myself into seated position, rubbing my eyes to adjust them to the darkness. At the end of my bed was a hovering shadow. Blink. Blink. *What is that? Who is that?*

It was him.

Woozy from all the beer I'd consumed, I didn't know which move to make next. "Jared?" I whispered in confusion. "What are you doing here? What time is it? How did you even get in?"

"Who is he?" Jared demanded. "And don't lie to me, I know you're fucking someone."

I certainly had every intention to fuck someone, but I hadn't yet. "All right, you need to leave. Not that it's any of your business, but I haven't fucked anyone."

"I don't like liars, Jess. I smelled your vibrator. You've been using it. You're only horny because you're fucking someone."

I'd noticed my vibrator looked out of place yesterday, but I had assumed I was losing my mind. I guess I was right.

What the fuck.

"Okay, psycho! I absolutely can't believe that you just admitted to breaking into my place and sniffing my vibrator. You need to go, or I'm calling the police."

Just then Jared lunged toward the bed and grabbed Libby. He held him in the air by one front paw. Libby screeched and flung himself about, attempting to escape.

"You even reach for your phone and I'll snap his neck. Understood?"

I covered my mouth in horror, absolutely terrified at the threat. I wanted to call his bluff, but I couldn't risk it. I had no doubts he'd kill me, so what was stopping him from killing Libby?

"Jared, please put him down. He's not a part of this! If you hurt him, you'll go to jail for certain. You'll be smeared to kingdom come in the

papers, and you'll never be able to be a firefighter again. That's not the life you want, is it?" I knew his career as a firefighter was a soft spot.

I watched Libby as he desperately tried to scratch him and get away. Jared sat on his response, knowing I was right, and angrily threw Libby into the hall. I heard him land on his feet and scamper away, poor Libby. I exhaled heavily and looked at my comforter. That was the longest two minutes of my life.

And just as mysteriously as he'd arrived, Jared left without another word. I was shaking with fear.

How dared he make me feel unsafe in my own home? He had to have a collection of keys to my place. I had so many questions. How long was he standing there? What was his motive; was he watching me sleep? How many times had he done this?? What would he have done if I did have someone there with me? I didn't sleep another wink that night.

The sun came up, revealing a new day. *I guess I should shower and get ready before calling a taxi to the hardware store.* I needed a new door handle immediately, and a screwdriver to install it. I should've bought stock in those suckers. I'd watched my dad do it last time. It was simple enough. I could do it myself. No need to involve him again.

I was in the bathroom after my shower, naked and dancing around with my music blaring as usual. I heard the familiar sound of the door clicking shut. *Fuck. It's him again.* I hadn't expected him to be back so soon. I quickly shut the bathroom door and pulled on my fluffy white bathrobe.

The door blasted open. I backed up in the corner of the small bathroom, next to the tub. There was nowhere for me to go.

"Please don't come in here," I begged with my arms straight out toward him.

"Jess, I'm sorry about last night. I don't know what came over me," he said before taking a long breath. He couldn't even look me in the eyes. "I wanted to stop by and tell you that. I understand why you left. I get it. I'm not good for you. I'll leave you alone from now on," he promised.

"Thaaaaanks...? But you could've, ya know, just texted me that," I snarled. "You scared the absolute shit out of me, Jared! Why are you like this? *You* ended us, yet you can't let go. Is it because it wasn't your choice?

I don't understand why you think you can control my life from the outside. Especially when you never allowed me to become a part of yours. For *years!* It's time you let me go. I'm not coming back, and I'm not sorry I left. I'm happy now. Without you."

My phone was still on the nightstand charging, and the text message alert sounded. We briefly made eye contact, and I could tell he was going to go for it. He was closer, and quick. He had it open and read before I had the chance to take it away. Fuck. Fuck. Fuck.

It was Lee. "Good morning beautiful :)" read the text.

"I knew you were lying. You fucking whore."

"Calm your shit. We aren't screwing, I just started talking to him. Besides, you expect me to feel bad about someone sending me a good morning text? You don't do that. Instead you try to kill my cat."

"You mean *our* cat."

"No, I certainly fucking do not. Libby is *my* cat," I said pointing to my chest. "And after last night, you'll surely never see him or me again. Now *get the fuck out!*" I balled my fists and stomped my feet, screaming like an immature child.

Jared walked by me like he was leaving, but instead he made a pit stop in the bathroom to grab a bottle of mild over-the-counter sleeping pills from the cabinet. I knew there were only a few in it, because they were mine. When you sleep next to a monster, you tend to need them.

I stood in the hallway, wondering what his master plan consisted of next. He grabbed me by my wet hair and flung me onto the black futon in the spare room. For a moment, I considered he might attempt to rape me as my robe flung open, exposing my naked body. But he didn't.

"I can't live without you. If you're really gone for good, I don't want to be here anymore. I'm going to end it, and it's all your fault. You can explain to my family why I'm dead. You could've stopped this. You'll have to live with what you did to me." He fumbled sloppily with the pill bottle, and he dumped the contents into his hand.

I couldn't contain my laugher any longer. When I say I was laughing, I mean the type of hysterical laughter where you can't catch your breath

and may actually piss your pants. If I'd been wearing pants, that is. He was fuming.

"What the fuck are you laughing at?" he loudly asked.

"Well, first off, you're an absolute idiot. Those six sleeping pills aren't nearly enough to kill you. Make you sick and fall asleep, probably. But your dumb ass will surely survive. And secondly, I honestly don't care if you die. It would save me a lot of trouble in life. I don't know why you think I care."

He already knew the pills wouldn't kill him. He just didn't think I'd call his bluff. But I wasn't who he thought I was, not anymore. In hindsight, maybe calling his bluff wasn't the best route to take, given that he had nothing else to lose.

A storm awakened in his eyes. They became so powerfully dark that I felt they'd suck the life from my soul should I glance at them again. He took no time before his hands were around my neck so tightly I felt his fingers could lace. I desperately tried to pry him off with my fingers, digging my nails into his hands, surely drawing blood, but it was useless. I kicked at him and attempted to scratch his face, but nothing was working this time. My vision became spotty. I couldn't breathe. *One. Two. Three. Darkness.*

I don't know how long I was out. But as I started to come to, my lifeless body was being shaken uncontrollably. He shook with all his might, crying like a lunatic, screaming out into the abyss that he was sorry. I kept my eyes closed for a bit longer, breathing shallowly, just to let *him* suffer for once. When I thought he'd had enough, I let out a loud gasp and opened my eyes. My windpipe felt like it had been crushed to oblivion. My head was pounding with fury as blood rushed back to it. I tried slapping him off me as he hugged me tight, rocking me back and forth, still sobbing.

"I thought I killed you. I thought you were actually...dead. You're alive! Uhh, I don't know what I would've done if I'd actually killed you. I'm so, so sorry," he whimpered through tears.

I stared at the floor, unable to blink as he rocked me back and forth. I wished I *was* dead. Why did God keep allowing me to suffer? Again and again. Why didn't he give me the tools to remove myself from this situation? *God, please rid me of Jared. I beg you. I don't care if it's through my death. I can't live like this for a second longer.*

I pushed him off as he was still blubbering about things that made no difference to me. His voice sounded like Beaker from the Muppets, and I didn't know the translation. I stumbled down the hallway with my hand to my head. I could hear him trailing behind me. I got to the front door and opened it gently. I stood there with it open, gazing out in the apartment's corridor, speechless. He was still bawling, but I wouldn't give him satisfaction by acknowledging it. Eventually he got the point and exited. I slowly shut the door behind him, without a word passing my lips. I didn't bother to lock it.

I went into my room, grabbed my phone, found the contact for Momma Collins, and dialed. She answered kindly, as she always did. My throat hurt, and it was painful to speak, but I did my best. "Beth, I need you to call your son. I don't know if you're aware...but I found out he was having an affair." Uttering those words was like taking a dagger to the chest. "I kicked him out a while ago. He has since broken into my home on multiple occasions to assault me. If he comes back, I'll make certain he's sent to jail. Beth, I'll press charges this time. I mean it. I've had enough. I know your family doesn't want that embarrassment, so I need your help keeping him away."

Family embarrassment was her weak spot. I knew she'd do what she could to protect the Collins's squeaky-clean reputation. That was why I was calling her.

"Oh my. I had no idea, Jess. I can't believe he would do this to you. We'll miss you." She paused. "But I understand where you're coming from. I'll do my best to make sure he leaves you alone. I appreciate you reaching out to me before calling the police."

"Thanks, Beth. I'll miss you too, but I can't put up with this anymore. He still has a lot of stuff here," I told her as I looked around the apartment, overwhelmed. "I'll coordinate a time for him to come and get it, but he's not to come alone. I want you and at least one other person to come with him."

"Understood. I'll pass on the message. Please take care, Jess."

"You too," I said before ending the call.

15

I'll get over him fast—one of the many lies I told myself. Physically I could give myself to someone, but mentally? Emotionally? Forget it. I promised myself I wouldn't allow the mourning period to last long. But it lasted much longer than I'd like to admit. It was challenging coming to terms with the fact that no matter how much I'd dedicated myself to him, I was never enough.

During the days, I was able to keep myself busy, but in the stillness of night, I'd feel the panic seep in. Vodka and wine tucked me in most nights, and if they didn't, I'd always come to regret it. Days rolled over, and weeks passed, but I took little notice. Staggering through life with a hangover tends to do that to you.

It was almost spring, and everything was mud. Walking to work, I noticed the soon to be yellow and orange flowers were budding, birds chirping from the trees and dancing together above my head. It's a wonder I noticed details through my bloodshot eyes. I had down a solid daily routine: gym, coffee shop, work, lunch, then maybe back to work. A barstool permanently held me at night.

Lee and I had become as much of an item as our commitment issues allowed. I could feel myself falling hard for him in the ways I was able. I was sure he'd realized how hard I was falling. When I got too close, I could

feel him recoil. I couldn't allow myself to go there, not with him. We had too much of a connection for him to be my rebound. I was hurting, and I knew if I ended up with him, he'd be hurting too. So in the meantime we enjoyed each other's company and warm bodies.

I could always count on Lee for a Sunday day-drinking spree. We'd drink, stumble to his apartment, hook up, and he'd let me stay overnight. In the morning I'd do the walk of shame to work, snag a cab, or he'd drop me off at home.

One night I let my feelings get the best of me, and I programed his coffee to brew in the morning as a surprise. He didn't say it, but I could tell it was too much for him. He had this invisible line I couldn't cross, but I tiptoed up to it often. Always wanting more.

After a night of drinking and rolling around in bed, he woke to get ready for a day of work. As he showered the scent of vodka off him and I waited for my ride, I made his bed ever so neatly. I didn't think much of the gesture as I was in the act, but the look on his face said it all. To him, we were casual, and my deed wasn't one you'd expect from a casual partner. I'd gone too far, and it was clear as day. He didn't ask me to stay that evening, or the following two.

As time continued, I could feel his interest dwindling. At an after-hours party, I saw him getting cozy with one of my high school friends in the kitchen. It was blatant that I was cock-blocking him.

I should've known. *I'm not enough to keep his attention either. I'm never enough.* Lee wasn't mine; he didn't owe me anything. Yet I still felt inadequate. Just like Jared, Lee had chosen someone else, even though I was here as an option. *Maybe something is wrong with me after all.*

■ ■ ■

The next few weeks, I decided to focus more on my friendships and try to forget about men. That didn't last long. It never did.

Leah came into the pub to visit me as my shift was winding down. That night we had grand plans to go to Lando's, a laughable dive bar of a dance club. It was over/under night, and despite our often-frequent nights

spent at the bars in town, we were still underage. She told me her brother Austin, whom I'd yet to meet, was going to stop by and help us out with the pregaming situation. Finding booze was never an obstacle for us.

Just then he walked by the giant picture window. When I saw him, my world stood still. He was impossibly tall. Real fucking tall, definitely over six feet. He wore tight-fitting skinny jeans, a well-worn black leather belt with silver-ringed holes, and a loose-fitting black shirt that read "Social Distortion." He was one of those lengthy, skinny guys that clothes never did justice to. I could see his arm tattoos peeking out from beneath his sleeve. As he came into the pub, he took off his black Ray-Bans, placing them on the collar of his shirt. His hair was long and dark, and he pushed it back as he approached us. I'd never seen a sexier man in my entire life.

He walked over to Leah, she handed him money, and they began to talk. I stood there, forgetting speaking was a function my body was capable of too. Drink tickets popped out of the printer behind me, and I paid them no mind. My eyes scanned him up and down, unable to believe the man that God had placed in front of me. Maybe God was listening to me after all.

Oh fuck. I'm in my ugly winter servers' outfit. No, no, no. I was clearly not prepared for this moment at all.

"Is this your friend?" I heard him ask in my direction as I snapped back to reality.

"Ugh...hi...I'm Jessica," I said with the least amount of confidence in the world. The feeling I got when I looked at his face was precisely what I imagined arriving at heaven would feel like. Impossible. It was unbelievable someone of his caliber actually existed.

He headed out, and I needed to know more immediately. *"Leah, what the fuck!?* You didn't once hint that you were hiding *that* for a brother," I blurted out.

"Well, I mean, he is my brother. We're all sexy," she said with her usual confidence, sealing it with a wink.

"You need to give him my number," I stated with conviction.

He messaged me immediately: "Hey, this is Austin, I got your number from Leah." That was fast; I admired his motivation. He wasn't fucking around or playing games.

"Heyyy," I wrote with an enthusiasm I immediately wished I could take back.

"So I guess we'll be seeing each other again soon," he wrote, followed by a smiley emoji. *OMG, he's flirting with me!*

"Oh, will we now?" I asked, being serious.

"Well, I got Leah what she asked for, and you guys are coming over here to pregame."

Yesssss. I should've known she'd be my wing girl. She was such a blessing to my life. I responded with a smiley and a "see you soon."

Lee sat at the bar and watched the whole exchange with interest and maybe a bit of jealousy. If he didn't want me to be his, maybe someone else would.

"Who's making you so giddy?" he asked.

"Wouldn't you like to know," I responded with a wink.

A few hours later, Leah and I arrived at Austin's as arranged. I was nervous walking in, because there were at least six other people there that I didn't know. I don't do well in random social situations, but I did my best. We got drunk on cheap, dry red wine while Austin and I partook in very awkward conversation, because I want to make this clear: we are both *very* awkward people. But my weird was his weird, and the familiarity made me feel safe.

Leah and I went out dancing that night. Several spectators watched on as we moved across the dance floor, giving them a show. Each creep that approached, we swatted away. We were only there to have fun with each other, but all I could think of was the tantalizingly tall man. When would I see him again?

Time flies fast when you're out of your mind. A week later I was "officially" dating Austin. I know, I know. With Lee I wasn't ready for commitment, but that was Lee, and this was Austin. It wasn't like Lee would've committed anyway. Austin, however, begged for my love and affection. If I would've let him marry me on the spot, he would've. He was romantic,

caring, basically every lovey-dovey descriptor that you could hope to give a man. Our sex life was out. Of. This. World. The passion we shared from the beginning was explosive.

Months went by, and not much had changed. The honeymoon stage was seemingly lasting forever. I was happy to see that Austin hadn't flopped on me in the way Jared had. What you saw was what you got with him.

Unfortunately, our work schedules didn't mesh well. He usually started his shift as a metal worker at six a.m. and would work over time. I'd often close at the pub and make it to his house just in time for him to be crawling in bed. I would put on some pajamas and crawl into the safety of his arms. He insisted I leave some clothes at his place, a level of seriousness I wasn't used to reaching so quickly in a relationship. His bed was impossibly tiny, but it didn't matter. I was safe, and Jared couldn't get me there.

I'd cut back a lot on my barhopping, opting to come home to him instead. I was fine with the downturn in the crazy lifestyle I'd created. His love made me want to be a different, better woman. But hidden inside me, tucked away, lay a miniature devil. It was burrowing itself deep within, and I couldn't ignore its presence for much longer.

April quickly arrived, and I was blooming along with the flowers. I continued working on myself emotionally and hitting the gym. My life felt separate from the one I had had just a few months prior. I decided I was in a good place emotionally, and it was time to update my journal on all the juicy new happenings.

Journaling has always brought me joy and given me freedom. I stopped writing during my relationship with Jared. In fact, I hadn't even opened my journal since he'd made it clear he read it. Just another level of happiness he stripped me of.

I grabbed the leather journal off my shelf, and its familiar smell began warming my heart. I jumped on the edge of my bed and ran my fingertips over the book's smooth cover and along the jagged, deckled edge. Carefully opening it, I flipped to my last entry. I needed to prepare myself for how much of my story was left untold. That's when I was unexpectedly smacked in the face. With words. *His words.*

"Yeah, kinda weird seeing my writing. I'm not trying to go through your privacy, but I'm writing something down that will be kept forever. I'm going to change. What I've done and said is not acceptable. No matter what wrongs I think you've done, you deserve a better me. A better us, and baby, I will man up and prove it. You deserve my best, and that's what you'll get. I'm sorry for everything, and I promise you, as permanent as this ink and book are, I will give myself back to you in the way you've wanted me for so long. I will always love you, my angel. Your baby, Jared."

The entry was dated February 27, 2009. I knew that date well: it was the day he'd tried to run me over. *No matter what wrongs I've done? Trying to deflect, even during an apology…well, if that isn't classic Jared.* What was this, some evidence that would clear him in court if he'd been successful in running me over?

No matter how hard I tried, I just couldn't get away from him. I rarely stayed at my apartment, because truthfully, I didn't feel safe there. So he wouldn't know I was home, I always kept the lights off. Late at night, I heard his SUV fly by with lights and sirens blazing on his way to the fire station, sending a chill up my spine.

The hotel he worked at was only a block away. I often heard the bass of his sound system as he crept by. I could always feel him watching. Waiting. I was a prisoner in my own home. I loathed that he had that power over me.

This apartment still wasn't mine. I looked over to a pile of his dirty clothes that still lay sloppily in the corner. A caricature of us still hung on the wall. His toiletries were in the bathroom. Shitty DVDs were out by the TV. His junk food filled the cupboards. *I need to rid myself of this poison.*

On multiple occasions I'd asked him to come get his shit, but I was never stern enough. I needed to be strong, or I'd never get closure. "Fuck this!" I declared aloud to no one in particular, other than myself and Libby.

I walked to the liquor store up the block and asked for a few spare boxes. It was time to pack up the baggage. I texted him and then called his

mom to relay the same message. He was to come and get his boxes that week, at a time mutually agreed upon, when she and at least one other person were present. If he failed to, his belongings would immediately be out on the curb, free for the taking. I wasn't obligated to be his storage unit.

I texted Austin to let him know I needed a night alone. Of course he was nothing but understanding. I opened a bottle of wine, poured the glass nice and tall, and popped on a playlist. I went room to room, removing every hint of Jared that remained. Some objects held negative memories, while others held good ones. Jared's belongings had tethered me to him for too long. This was the closure I needed to make him cease to exist within my life.

I piled it all in the spare room, stepping back looking at the pile with pride. It hadn't occurred to me before, but looking at those boxes, it became clear: this was another game. I understood his refusal to pick up his belongings gave him some sick, lingering power over me. Austin rarely came to my place, because it felt like it wasn't mine to share. I'd been unable to be here without Jared's energy hovering over me. He wanted me to feel uncomfortable; it gave him a subliminal sense of control. But that was all ending. *I'll be cleansed. Free.*

We arranged a time on my sole day off for them to come get the boxes. Jared wanted a later time, but for once, I called the shots.

I didn't know if it was the safest choice, but I needed Austin there for emotional support. I asked him to come.

"Of course, babe. What do you expect out of me while I'm there?"

"I just need you to sit in my bedroom so I don't feel so alone. I need someone there in case something goes wrong."

"Good idea," Austin agreed, kissing me on the forehead. "It will all be over soon."

Austin was so different than Jared. He was sensitive to my feelings, and I knew in the bottom of my heart, if I stayed with him, I'd never be hurt. He hated abusers and cheaters. Hell, he couldn't even watch a movie where the characters were either of those things. I admired him for that— for his morals.

As usual, I hadn't told him everything about Jared; it was a story I preferred not to share. The less I talked about it, the less real it felt. But in moments of comfort, I did divulge some details. Austin hated both Jared and Lee. He thought Jared might as well be the devil, and he felt Lee wasn't a good guy. He believed Lee had been using me and never cared about me. Austin stated both of them were incapable of being faithful. Maybe he was right.

I was glad that Saturday morning when Austin arrived early to my place, Wegmans coffee in hand. He'd chosen not to work overtime and to support me instead. I appreciated the gesture. I was a pot of coffee in, and my hands were trembling. I paced back and forth through the apartment, double-checking everything to ensure I'd gotten it all.

Elliot and Beth had agreed to come with Jared, per our original agreement. I was both thankful and sad about their imminent arrival. I loved his family like they were my own. When I lost him, I lost them too. Today would have to be my closure with them as well.

I was scared to see Jared again. Yes, I hated him, but what if some harbored feelings reemerged? I'd come so far and done so much work. I couldn't afford a setback now.

At noon I heard the heavy hallway door open, and his booming voice permeated my ears. They were assembling outside my door, on time as expected. Beth wouldn't have allowed them to be late.

I was sick to my stomach, but I'd manage. *I can do this!* I'd been through much worse than anything that could happen in these moments. I'd put all of his stuff together so I didn't have to deal with this situation any longer than necessary. *I'm prepared. I'm in control.*

I opened the door and welcomed them in. *Awkward, so awkward.* Beth stepped forward and drew me in for a hug. I began to tear up, but I wouldn't let him see it. This was going to be harder than I thought.

"Jared, I've put all your stuff in boxes in the spare room," I said. "I figured it would be easier for us both if you could just grab and go. If there's anything in those boxes you don't want, feel free to throw it out. I don't want it. I'm pretty certain I boxed anything that was yours."

"Okay. Guess I'll start loading boxes. Come on, Elliot," he said, gesturing down the hallway. He seemed to be in a decent mood.

The spare room was located across from the bathroom, toward the end of the hallway. At the very end of the hallway was the door to my bedroom, which was propped open. As he got to the end of the hall, he stopped, and I watched his body language change to the monster I knew well. *Austin.*

Jared looked back at me. "I see you brought your fuck toy with you."

I rolled my eyes. "I didn't bring anything with me. You're in my home, remember? Who I have here isn't your concern. You gave up that privilege long ago," I proudly stated.

Sounds of Jared thrashing around in the spare room filled the apartment. He just couldn't resist the temptation to act like an infant. It was almost laughable. He came out with a box and a few odds and ends that weren't his.

"I'm taking this!" he proudly proclaimed as he walked by me, waving my lamp in his hand.

It was just a lamp; I didn't attempt to stop him. He came in, grabbed his box of DVDs, and then stopped by the living room, adding mine to the box as well. "I'm taking these too," he grunted.

"Whatever, Jared, just get your shit and go," I mumbled with frustration. *It's just stuff, it can all be replaced*, I reminded myself.

"Ugh, are those his?" Beth asked.

Cocking my head to the side, I sarcastically responded, "What do you think?"

"Jared! Stop acting like this. Just take what belongs to you so we can be done with this," she scolded him. I was happy she was here. I felt oddly like she was *my* mother, protecting me as one of her own.

As we stood by the doorway, watching the boys leave with the boxes and return empty handed, she gestured toward a trunk, perfectly placed in the entryway. It was a beautiful, worn-in, army-green trunk with broken brown leather straps. She'd given it to me as a gift when Jared and I were together because she had several, and she knew how much I loved it. I had very few possessions in the large apartment, but of them, that chest was

the only thing I truly loved. I had it stockpiled perfectly with all of my crafting supplies, scrapbook materials, and photo albums.

"You know. I've been thinking. This would look nice in my entryway."

"You mean a similar one?"

"No. I mean that one."

"What? But you gave that to me as a gift," I said, fighting back the building tears.

"I know, but since you guys aren't together, I think it's time I get it back. Don't you?"

I was being punished for everything that wasn't my fault. I stood there, defeated, staring into the distance in disbelief. She wasn't one of my allies; she too was an enemy. I felt such a deep sense of betrayal. It wasn't about the stupid chest. It was the principle. She didn't need the chest, and she knew what it meant to me. She was well off and had a house full of treasures. I'd had nothing when I met her family, and that was exactly how they intended to leave me.

I opened the chest and began taking out my treasures, at first placing them gently on the floor. As I got deeper and deeper, I had half my body bent over inside of it. I began wildly tossing my shit next to it with anger. *How fucking dare she!*

The trunk was the last thing that needed to be taken from the apartment. They would've taken my soul too had I let them. When it was empty, I slammed the lid and said, "All set," in the only rude tone I'd ever given her.

The icing on the cake was that Jared was at the end of the hallway, talking shit to Austin. Austin boldly sat, scrolling through his iPhone, not giving him the time of day.

"She's a slut, you know. You don't mean anything to her. You're just her fuckboy of the week," was all I heard before I made my way down the hallway, screaming.

"*Jared!* Leave him alone. This is between you and me. Our breakup had nothing to do with him and everything to do with your actions."

Jared quickly came down the short stretch of the hallway that remained between us. I backed up as he approached. He pushed me into the wall,

pinning my face to the side. He got within what felt like a centimeter and said, "That's right. I cheated on you. I'm better off with her. You're trash, and you'll always be trash. I was fucking her the whole time, and I don't regret it. Remember how late I was the day I proposed? Yep, I was inside her just before that. When I was inside her, I never thought about you."

Just then Elliot pulled him off, saying, "Stop it, let's go." Jared backed off, then lunged at me, taunting me. Austin stood up, waiting for me to say the word.

"Jared!" his mother yelled from the doorway.

"I hope I never fucking see you again!" I yelled after him as he slammed the door. I stood there in silence, staring at the door until the wood grain was etched into my brain. I was shaking uncontrollably. I wanted to cry, but I couldn't. I knew what he said was true. He'd been with her the night of our engagement. But what did that matter? The betrayal was a betrayal no matter the timeline.

Just then, I heard quiet, controlled steps approaching. I didn't turn around; I was safe now. Austin wrapped his arms around me, lacing his fingers at my stomach. His body overwhelmed mine in every way I needed. He placed his head atop of mine, gently kissing it. "It's all over, babe," he whispered as I let my body melt into his. His love was so beautiful and nonjudgmental.

■ ■ ■

Spring turned to summer, and with the change of the season came an even stronger relationship. I could tell if I let my guard down, it would be the real thing. I couldn't go in 100 percent though. Why couldn't I? It wasn't fair for Austin to give me his all and not get my all in return. Even knowing this, for some reason I couldn't fully commit myself.

Over the next few months, his love began to smother me. I'd still been hitting the gym regularly, but honestly it was a bit aggravating to go. When I was there, I'd get several messages from Austin about how much he missed me and wished I was home with him.

He was so overbearing. I wasn't used to this. Not used to someone giving a damn if they were with me or not. But I decided I could meet in the middle. I needed to try to let myself be loved. As the weather became nicer, I began spending more time doing physical activities with him and less time at the gym.

His parents lived in a beautiful part of the countryside, a few towns over. Their property was a family-owned dairy farm surrounded by woods. If you wanted to go for a killer hike, this was the perfect place. I'd often join Austin and his siblings to trek through the area. After a few hikes, Austin asked me if I'd train for a canoe race with him. Despite the fact that I wasn't athletic in the least bit, I said yes. I could see it meant a great deal to him.

We spent countless hours on the river near his parents', just the two of us, rowing along. He taught me the proper technique and never once showed me frustration. When the day of Race Fest came along, I felt a sense of pride. Austin always participated in the canoe race, and he *always* took first place. He had confidence that we would do just as well as a team as he did alone. I don't know what made me more ecstatic, his confidence in me or the fact that we did take first. We didn't have many competitors, just Nate and Leah with their leaky canoe, but that wasn't the point. I'd never entered a race before, and I'd agreed to be a part of something and stuck to it. It was a monumental hurdle in my life.

But after the training and the race were complete, I felt myself getting stir crazy. I didn't get it. We'd been dating a few months, and things were going well. So why did I feel the need to self-sabotage this? Why did I want to run?

Austin was still worried about Lee and brought him up often in random conversation. He knew Lee still came in to work daily, and he felt threatened by it. Not that I'd tell Austin, but I didn't blame him. Lee still had something over me. The man I wanted but couldn't have, I suppose.

One Thursday we attended a local event with everyone else in town. The event was called the 2300° and was held at the Corning Museum of Glass. If you're not a local, what I'm going to say probably sounds ridiculous. CMOG is a world-renowned glass museum. During the winter

months, the citizens of my town, much like every other, get stir crazy. To deal with the mundane days of winter, the Gaffer District puts on events to keep us from getting cabin fever. This event is one of those. 2300° occurs at the museum one Thursday each month during the winter. Locals either dress up nicely or come from work already snazzy. They then buy cheap drink tickets to trade for local wine or beer, and they jam out to whatever entertainment was hired for that night. I'm not sure whose genius idea it was to gather a bunch of drunks in a museum filled with glass, but I was more than there for it.

Austin and I went together, looking fabulous as ever. He really did clean up nicely—not that he had to do much to take my breath away. *Look at me*, I thought, *on the arm of one of the better-looking guys here*.

We were planning to meet Leah as well, and I was going to join her for some drinks on Market Street afterward. Austin, of course, had to go home and to rest for his early shift Friday. I was thankful he had to go home early. Girl time with Leah was just what the doctor ordered.

Shortly after arriving, we began scanning the massive crowd for Leah. No sooner did we find her than we crossed paths with Lee, who kindly stopped by to ask what we were up to. It was blatantly obvious Austin felt threatened. Why did I have a weird sense Lee was trying to size him up? It was hard not to notice them watching each other like hawks the rest of the event. Both interesting and very, very awkward. What was Lee up to?

As the event wound down, I could tell Austin had become nervous about the prospect of me being on the town with a drunk Lee running around. He made me promise several times that he had nothing to worry about and that I was over Lee. I promised, and lied. He went home, and Leah and I went to the pub to meet up with Nate. I knew without a doubt that Lee would be there, but I went anyway. On purpose.

Lee's eyes lit up as soon as I walked in the bar without Austin in tow. We drank a few pints together at the pub as Nate closed up around us. It felt just like the old times—Leah and Nate, Lee and me.

Lee and I asked them to meet us across the street at the Gaffer when Nate finished closing. Leah looked at me with suspicion but agreed.

When we exited the pub, Lee asked, "Can I talk to you for a minute before we go to the Gaffer?"

I said yes, even though I knew I couldn't be trusted to be alone with him.

In the darkness between buildings, he confessed how jealous he was of me and Austin. "I don't want you to be with him. I hate seeing you together. You should be with me, and I know you feel that too. I was stupid to let you get away. Please, Jess."

I was euphoric and angry all at once. *"How dare you!"* I yelled. "Ughhhhhhhhh. You couldn't have come to this conclusion months ago? Now I've been with him so long. What am I'm supposed to do? Just leave him for you? At the slight chance that *maaaybe* you can suddenly commit?"

Lee put his arm around my lower back, pulling me in, and kissed me with fury. I didn't resist, nor did I think twice about Austin. I was a wrecking ball, and I didn't care who was hurt in my path.

Eventually I pulled away, shooting him the evil eye. I playfully slapped him in the chest as I caught my breath. *This is not how I envisioned tonight going at all.*

I dug in my purse for my phone, which had gone off several times since we parted ways with Nate and Leah. I had a few texts from her: "Jess, where are you? I can't find you anywhere. Austin called me. I didn't know what to tell him. He knows you're somewhere with Lee..."

Five missed calls, one voice mail. Two from Leah, three from Austin. *Fuck. I didn't want to involve Leah in this.*

"I need to listen to this," I told Lee.

I walked out alone into the alley, put in my password, and listened. Austin was bawling and completely beside himself. *Fuck.* He was worried because he knew I was pretty intoxicated by this point and that the others couldn't find me. On top of that, he knew I was with Lee. Austin begged into the dead air for me to tell him that somehow he was misunderstanding. But I couldn't do that. So instead, I did the most heartless thing I've ever done.

I opened a new message, plugged in his contact, and began typing. "I'm sorry to do this through text, Austin, but it's over. Please don't try to find me, or call." Send. As soon as my phone read "delivered," I shut it off.

I turned back to Lee, who was still waiting for me in the darkness. "Let's go back to your place," I suggested with a smile.

I'd like to say I learned something from that situation. I'd like to say that I began treating people better and caring about other's feelings. Truthfully, it took me years to get to that point. I was a tornado, willing and waiting to crush anything and anyone who stood in my way. I had so much healing I needed to do, and I didn't give myself time to do any of it.

Years went by, their memories nothing but a drunken haze. Lee and I were on and off for many of them. We'd break up, and I'd immediately attempt to fill the void with another man. Those relationships would fare well at first, but eventually they too saw my brokenness, and they didn't want to stay around long enough for me to fix it. Lee and I would fall back together out of habit, until we didn't anymore.

■ ■ ■

It was 2012, and I was going to Corning Community College for my associate's degree. Lee encouraged me to go to college, which I'll always be grateful for. He believed in me when I even I didn't. Going to school gave me a sense of purpose. It made me feel I had power over my life, which I desperately needed.

I was studious and dedicated as much time as needed to getting straight A's. Nothing else was good enough. This new drive, this new priority, got in the way in my relationship with Lee. He was used to being first in my life, and having to share my attention proved to be too much for him.

We split on good terms, remaining friends. After that, I fell back into bad habits. Even though our split was amicable, I still derailed. I was living alone again and bartending at Maley's, the local hot spot. Every waking moment, I was at college, the library, or on either side of the bar at Maley's.

Over my summer break, I met Max. His friends were a group of regulars at Maley's. He was a bit taller than I, with light hair and eyes like the ocean. He dressed in a classy way that not many men in Corning do. He was arrogant, persistent, and belligerent at times. He was the dick of the group for sure, which only made me want him more.

Max reminded me of Ryan Phillippe's character in *Cruel Intentions*, in both looks and personality. It wasn't long before I found myself falling hard and fast into a relationship with him. His pull was impossible to resist.

I was only with Max for seven months, but it felt like a lifetime. Max was much like Jared. He too carried a darkness in him, and got off on making me suffer. But that's a story for another book.

After I escaped Max, I tried hard to focus on myself again. I'd built myself from nothing after Jared, and I could do it again. Every day a drunk patron would try to knock me off my path of self-discovery, some caught my eye, some didn't. I wasn't interested in pursuing anyone.

Two months before I left Max, I walked into Maley's, and there my life stood in front of me. Blue jeans, high-top Nikes, a worn-in gray Buffalo University T-shirt, and a tattered Yankees hat. Somehow everything about that moment was both nothing special and everything extraordinary. I'd never met my husband until that moment. But as far as the timeline of my life goes, that—that was where it all began. Corey. He is my happy ending.

16

Dear Jared,

It's painful to think about how long I spent turning my life around after you. How was I expected to move toward the light when the comfort of darkness was all I knew? Like a caged animal who'd never seen the light of day, I recoiled from it.

It's been ten years, and I still have questions rattling in my brain. "How could you do that to me?"—a decade-long, screaming question. While I smothered you in the warmth of my love, you were hell bent on being frigid.

You put me through so much shit. From your secret child to the lies, the control, the constant mental and physical abuse. You had to add insult to injury, didn't you? You didn't realize your infidelity would be the last straw, the one that couldn't be forgiven? Even I have my limits. It's pretty sad that when I realized you were cheating, there was no element of surprise. It was so on par for you. Lord knows how many times you'd been unfaithful and I didn't catch you. *But I got you.*

At first it was hard to live without you. Impossible even.

I hated you with every atom in my body. Except one; it always bounced around, wreaking havoc where it could. That one had hope and yearned for you to be different. It wanted you to come for me one last time. Not in

anger but in apology. That atom wished that for once, you'd just fucking care about what you did to me.

That atom was stupid. Atoms always are.

When your grandpa died, and I was dating Lee, you asked me to attend his funeral with you. And I did, out of respect for him and your family. I hadn't seen you in what, about a year? I thought you'd apologize to me. I thought you would say something about how it all ended. Instead you made a joke about how Brianna wanted to get married, and how you should give her my old ring. Heartless. But that's what it took to rid me of that last hopeful atom...

When I kicked you out, you took my belongings, but you also took my fucking soul. You broke me so badly that no longer had an identity. Everything that once made me *me* was gone. I had no interests, no hobbies, and my old friends had left my side long before, all thanks to you. I had nothing. I was nothing.

Who was I before I met you? I couldn't remember. What music did I enjoy? What food did I eat? Was I still fat if you weren't there to tell me so with every bite I took? How could I possibly make decisions without your permission?

You would've thought rock bottom was a proper place to build from, but I was scared to begin the construction.

I often wonder what it's like to live without fear. Not fear of stupid things like the boogeyman lurking in the closet, but a fear of you. You're real; you're my monster. I regularly found you lurking in the darkness, and I still wonder if you'll reappear. Are you still there? Waiting? Do you still want me to die?

Every so often, as I'm falling asleep, I'm troubled by your memory. I can feel your hot breath, breathing powerfully over me in the dark. I freeze for a brief second, unable to exhale. I have to remind myself it's my imagination, and I squeeze my husband's hand as he sleeps. *Safe.*

I find myself gazing into the night's shadow before shutting the curtains, and even though I'm stories high, I expect to see your dark eyes peering back.

I check to be certain our door is locked before bed. And then I check again. Even now, as my dog's barking toward the door, I jump, startled by the thought that it's you. Security at the front door, countries away, and still...I jump.

When I visit our hometown, my eyes dart around each parking lot, searching for any figure resembling yours. Prepared to do whatever's needed should you approach me.

Your old SUV haunts me. Its ghostly reflection pops into my rear view. For a moment my heart feels it may burst out of my chest, and panic takes over. In my mind you've found me; with a flash of rage, you'll run me off the road. It's irrational, because you don't even drive that vehicle anymore. But PTSD isn't rational. Not that you'd know.

The couple fighting in public gives me flashbacks. All you did was scream, and I can't tolerate the noise. The thrashing of his words are knives to my eardrums. I often see you in the face of other men, in their mannerisms, in their language. You'd be surprised how many yous are out there. *You aren't fucking special*, trust me.

When I hear a car's sound system booming in the distance, slowly approaching, I wonder if it's you. Do you know where I'm staying? Are you here to finish what you started?

I assumed in leaving you, the darkness would go too. But is that even possible—is the darkness always present once it invades us? Curling up inside our bones like a plague eating us alive? I think so.

It's no exaggeration to say the aftermath your storm left inside me was worse than any disaster I could've imagined. If people could only see inside of me on the six o'clock news, the way they see a hurricane's destruction, they'd want to fix me too.

But they can't. Only I have that power. Read it again. *I have the power.* I know you're gritting your teeth as you read those words.

My husband and I moved out of the country, which you already know. You always kept tabs on me, even from a distance. The shadow of you that lives inside me goes everywhere I do. It has enough frequent-flyer miles to be a platinum member, but at least I don't get charged extra baggage fees. The shadow is a weight only felt by me. Carrying weight like that for

so long changes a person. That fear has morphed into strength, and I'm more powerful than ever before. The obedient, meek girl you knew before ceased to exist. You couldn't kill her, so I killed her for you.

I've seen pictures of you on the news, being touted as a brave fire-fighter. But I know the real you, coward. If they only knew the man that does the saving is the man so many needed to be saved from. Narcissists love heroic jobs, don't they?

I know I wasn't your only victim. But I wonder, is the secret villain still up to his old tricks?

■ ■ ■

Remember that time you tried to kill me? No, not that time. Or the other. The time you strangled me until I passed out? It's a few chapters back if you need a refresher. I'll never forget the look on your face when I came to. You thought you'd actually killed me. And I kinda wished you would've.

In low times I think God wronged me by allowing me to live. The moment I took that breath, it gave you the belief you still had power. That you still controlled my every waking breath. You didn't deserve to believe that. Jared, you deserve to be in prison for all you did for me. You're lucky I didn't have the strength then that I do now.

Even though my strength is forever growing, that taste of death never left me. When God pulled me back to earth that day, a parasite came through too. PTSD, anxiety, depression, whatever the fuck we are calling it today. When you lost control of me, the parasite took over. It almost won several times. Bottles of pills whispered to me from the medicine cabinet. Water rushing beneath bridges begged me to jump. Trees pleaded for me to collide. But every time I was tempted to listen to their calls, I knew living was a better fuck-you than dying would ever be.

Do you see this? Do you see me? Living. Thriving. Surviving, *without you.*

■ ■ ■

I'm repulsed by this admission: when I left you, there was a void I couldn't shake. I tried to fill the black hole with alcohol; I'm sure you heard. You likely reveled in knowing you caused my downward spiral.

Alcohol helped me be the life of the party—intense, confident, and sharp witted. The girl I wasn't when I was sober. I indulged before work; a few drinks wouldn't hurt. A customer wanted to buy me a shot? You sure you don't want to do two? At last call, you were sure to find me falling off a barstool at the Gaffer, a bottle of Patrón deep.

I was drowning in alcohol, forgetting I couldn't swim. I'm sure people thought I was an alcoholic, but I wasn't addicted to the booze. I was addicted to forgetting you. I didn't drink for the fun; I drank for the blackouts. The time in between the last shot I remembered and when I woke up in the morning—*euphoric*. I lived for that. That's where happiness had a home. At least for a short time.

But as expected, alcohol began to ruin my life. In ways even you couldn't. Many men asked me to cut back or to stop all together. But I couldn't, or wouldn't, rather. That's the only time frame you weren't invading. I couldn't give up that glimmer of happiness, so instead I gave up the men. I drank until I faded away, because happiness came at the bottom of a bottle.

Whether they were fueled by tequila or whiskey, my drunken actions fucked up plenty for me. They continuously caused me embarrassment and forced me to apologize for shit that I couldn't even recall. After a while, shame was all I found at the bottom of a bottle. Happiness had moved out and didn't bother leaving a forwarding address.

It took me ten years, but I can finally say I no longer have to drink you away. To be honest, many days I can't even remember your face. And that in itself is happiness.

■ ■ ■

You never knew how to love. Not me, not anyone, for that matter. You know what they say: never trust a man who doesn't respect his mother. All you knew were insults, disrespect, manipulation, and control. On a list

of abusers' characteristics, you could easily check off each one. The list would build a perfect description of you.

Like a magician, you tried to trick me. You told me situations didn't happen the way I remembered, forever gaslighting me. You claimed your actions were for my protection. The good, the bad. You boldly claimed your actions were out of love. But one day, the lies piled too high and came crashing down. They shattered your smoke screen. And for once, I saw the truth.

Each insult you hurled at me was a brick I used to build my wall. When I left, my walls towered higher than anyone was willing to climb.

I'd give myself to men, hoping they'd fill my void. They never did. "Why are you like this?" they'd beg, time and time again. I didn't even know where to start. Even if I told them, would they listen? Would they care? Would they even believe me? They'd lay down a bed of flowers for me to walk on, but all I saw was broken glass. Anytime kindness was shown, I'd recoil. It couldn't be real. But it was more real than anything you'd ever shown me.

I was trapped in the belief that I didn't deserve love; that was your fault. I'm the book you kept opening but never got around to reading. "You're worthless. No one besides me will ever love you." It was branded on my brain, a mantra I lived by.

I took zero ownership of my pain, or my healing, for that matter. "Take me or leave me" became my self-destructive motto. And eventually they would. They always left. I don't blame them. There was a lot wrong with me, which I'm sure is satisfying for your sick mind to read.

Along with my self-destructive motto, I also gained a sense of independence. I had a fuck-you attitude and a chip on my shoulder I couldn't shake. I was hot and cold, and they never knew which me they'd wake to. I didn't need anyone. This life thing, I could conquer it alone. And every time I was left, that independence grew stronger. I straddled the line between the overwhelming need to be loved and wanting to run. It was a line I walked often.

I became a serial monogamist. I would date a man for months or years until he decided I was too damaged to love. Tossed aside like an old toy

Christmas morning, I hoped someone would come along and think I was good enough to play with. Someone would, and the cycle would repeat.

Friends urged me to wait before jumping into another relationship, but I refused to be alone. My brain may've been independent, but not my heart. It screamed to receive the love you never allowed me to collect. I promised myself I'd never date another you. But I did. Despite that horror show only lasting seven months, it aged me a lifetime. You two shared the same soul in different shells. Despite your eyes being brown and his being blue, they were identical, and that's something I'll never forget.

After meeting him, the confidence I'd worked so hard to build came crashing down around me. I became a version of myself I never thought I'd be. After enough time, the abused becomes the abuser. I'm not ashamed to say I fought back. But I held onto anger so tightly that it became a constant emotion for me. I didn't even recognize my reflection.

I have to ask, how do you live like that? Doesn't that much anger burn you from the inside out?

I'm free now. Free from him, and free from you. I broke his shackles, just as I did yours. Now I have a love that rocks my world, and he's never put me in chains. Rather he encourages me to fly. Sometimes my wings feel broken, so allows me to borrow his.

The scars you inflicted once covered my soul, but they're fading now. Corey is ointment to my wounds. His love like that warm cup of cocoa after a long day of playing in the snow: warm, satisfying, and everything you crave. You would swim in it if you could. But you can't. Because that love is *mine*.

With him I'm able to soar like the free bird I was always meant to be. I can live uncaged, like a woman ought to. You should to let your partner try it sometime.

Corey and I were married on a sweltering Saturday in July. During a moment alone, I smiled as a tear rolled down my face. I smiled because you weren't there. You're wrong, I am lovable.

It's gratifying knowing I've made zero place for you in my current life. Those closest to me haven't even heard me utter your name. Most have no

clue that I was previously engaged. That I almost married a monster. That you tried to steal my life.

That's because you *don't. Exist. To. Me.*

■ ■ ■

You claimed I was a worthless scumbag who'd never amount to anything. You were wrong. That money I saved for college, that you siphoned from my account? Don't you worry your little head about it, because I saved it up again. And I took my ass to school. I did that *by. My. Self.* I did that in spite of you.

Every ceiling you built for me, I crashed through. I graduated from a state university in Pennsylvania, top nine in my class. Guess I'm not as stupid as you claimed, huh?

I took the pain you gave me and wrapped it up as a little gift. I own that shit now. I earned my degree in social work, and I'm so fucking proud of that.

I used that piece of paper to save women and children from toxic situations just like ours. I was able to relate to them on a level other social workers couldn't. Those women, those kids, they picked up on that.

As an intern I created a guide for working with victims of domestic violence—for fun. They insisted I present it to the entire department, and now workers use it in the field. Later I was invited to Elmira University to share it again, and you bet your ass I did.

I. Did. That.

I turned my pain into something positive, something to help heal others. Bet you didn't expect that, did you?

■ ■ ■

From the bottom of my heart, I thank you. Thank you for cheating. Thank you a million fucking times. In leaving, I lost a lot, but what I gained is invaluable.

The life I had with you wasn't worth living. In fact, I wasn't living at all. I was a puppet that merely existed to have her strings pulled. But I own scissors now, and those strings are severed for eternity.

Sometimes I imagine what life would've been like if I'd stayed. I would've never known what it was like to have love reciprocated. You were never anything but hollow company. I would've never known the magic of life. I would've never gone to school, traveled, or had a career. You would've made sure of that. And surely I would've never known how talented I could be. That I could write this book in spite of it all.

So with this I say fuck you, and goodbye. This. This is the closure I needed.

Wishing you a warm seat in hell,
Jessica Hmiel

EPILOGUE

As a reader, you may be wondering what messes I've gotten myself into as of late. To say it's been a hell of a ride is a bit of an understatement. That fateful day that I walked into Maley's and met Corey, I had no idea my life would change forever.

I was still with Max, and Corey was with a long-term girlfriend. When I was bartending, Corey would constantly try to hook me up with his friends, which made for decent humor for his wedding vows years later. When we found ourselves newly single at the same time, he was persistent in his chase for me. For once in my life, I played hard to get. The baggage that was Max and the trauma that was Jared held me down.

But Corey wasn't scared of a challenge.

He had an enchanting aura, and I wasn't sure how long I could resist it. In disbelief that he was the man he presented himself as, I asked around about him, trying to dig up dirt. Much to my surprise, there wasn't any to find.

Eventually, despite my pessimism about our chances, I reluctantly agreed to a date with him. In a text with my friends before the date, I said I didn't think it would go anywhere, because he was "too nice."

Seven years later, Corey's still too nice, and it's just what I needed.

He shows me love when he starts my Saturday with the perfect cup of coffee. He plays my happy song when I'm feeling down. He'll choose

a vegan dish when we go to a restaurant, just in case I want to have a few bites when it arrives. A million little things that add up to the perfection that is him.

I don't know what it sounds like when he yells, because he's never raised his voice to me. Or his hand. In an emergency, he's the first person I call, because he's dependable. He'll be there. I thrive because he gives me the space to grow and encourages my individuality. When I have a win, he's there clapping the loudest, with a bottle of champagne in hand. With him, my worries are silenced. With him, I'm loved.

I'm aware this all sounds like I'm applauding a fish for swimming. These are all things husbands *should* do. But I've only ever known toxic love, so for me, a marriage like this is nothing short of a miracle.

Miracle or not, we've had our ups and downs. We're only humans after all. He's held me as I've cried when the past traumas have been too much. We created a baby out of love and mourned the loss together. For years we struggled to become parents, but our baby boy made it all worth it. We lived in China for three years, most recently in Wuhan. Our son was only a few weeks old when the disaster of COVID hit. We had to be rescued by the US government, uprooting our whole lives in an instant to provide a safe upbringing for him. It was hell, but I'd do it all again with Corey by my side.

Corey was the glue that held me together when I suffered from post-partum depression and anxiety. Past PTSD and new PTSD from escaping Wuhan plagued me at the same time. I was challenging at times, impossible even. But instead of withdrawing, he loved me harder. Corey's always looked at my flaws as a challenge, not a burden. Something that we could fix together. With him I've healed. I've grown. I've become me.

I know who I am now, and I'm learning to love that person a little more every day. I'm at my best when I'm driving on a country road, surrounded by trees whose leaves have been tie-dyed by Mother Nature herself, rap music rattling my bones, and despite the autumn chill, an iced oat latte in hand. The bulk of my time is spent drawing, cooking vegan food, reading, watching horror movies, enjoying the outdoors, blogging, or entertaining my son.

I hold strong opinions, which does tend to make me stubborn, but at least I know my opinions are my own. I'm passionate, intelligent, self-aware, resilient, empathetic, kindhearted, and creative. I'm persistent in advocating for others—minorities, animals, children—and I won't be quiet about it either. You can always count on me for a good laugh or honest advice. I'll take your secrets to the grave, but I'll overshare my own. I feel everything a little too deeply and have a fierce desire to fix others. When I love, I love with every fiber of my being, which is both one of the best and worst things about me.

I'm an intense person, which I've come to terms with, because that's authentically me. My eighteen-year-old self would be thrilled to see how far we've climbed.

Every night I fall asleep in a home Corey and I created together, with the soundtrack of our happy sleeping baby on the monitor. Our two rescue dogs take up more than their portion of the bed. Our love created all of this. And I know our love will continue to create more.

RESOURCES

The National Domestic Violence Hotline
www.ndvh.org
1-800-799-7233 (SAFE)

National Dating Abuse Hotline (for teens)
www.loveisrespect.org
1-866-311-9474

National Center on Domestic Violence, Trauma & Mental Health
www.nationalcenterdvtraumamh.org
1-312-726-7020 ext 2011

National Suicide Prevention Lifeline
www.suicidepreventionlifeline.org
1-800-273-8255 (TALK)

Women of Color Network
www.wocninc.org
1-800-537-2238

Battered Women's Justice Project
www.bwjp.org
1-800-903-0111

National Gay & Lesbian Taskforce
www.ngltf.org
1-202-393-5177

Men Stopping Violence
www.menstoppingviolence.org
1-866-717-9317

National Sexual Assault Hotline
www.rainn.org
1-800-656-4673 (HOPE)

National Institute on Alcohol Abuse & Alcoholism
www.niaaa.nih.gov
301-443-3860

Center for Substance Abuse Treatment
1-800-662-HELP

National Runaway Safeline
WWW.1800runaway.org
1-800-RUNAWAY
1-800-786-2929

National Child Abuse Hotline
www.childhelpusa.org
1-800-422-4453

National Center for Elder Abuse
www.aginginplace.org
1-855-500-3537

AUTHOR BIOGRAPHY

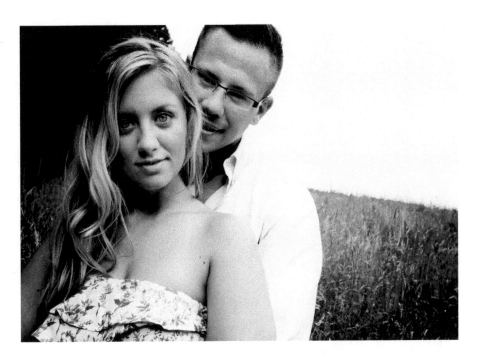

Jessica Hmiel earned a BA in social work from Mansfield University, after which she worked investigating child abuse cases. She and her husband have since travelled the world, and even lived in China for several years. When the COVID pandemic began, they and their young son relocated back to Corning, NY, where Jessica has focused on her passion for writing during quarantine. She plans to return to social work soon, hoping to serve victims of abuse, helping to guide them toward a path of healing.